Teenage C

THE
SIN-STEEPED
STORY OF
TODAY'S
"BEAT"
GENERATION!

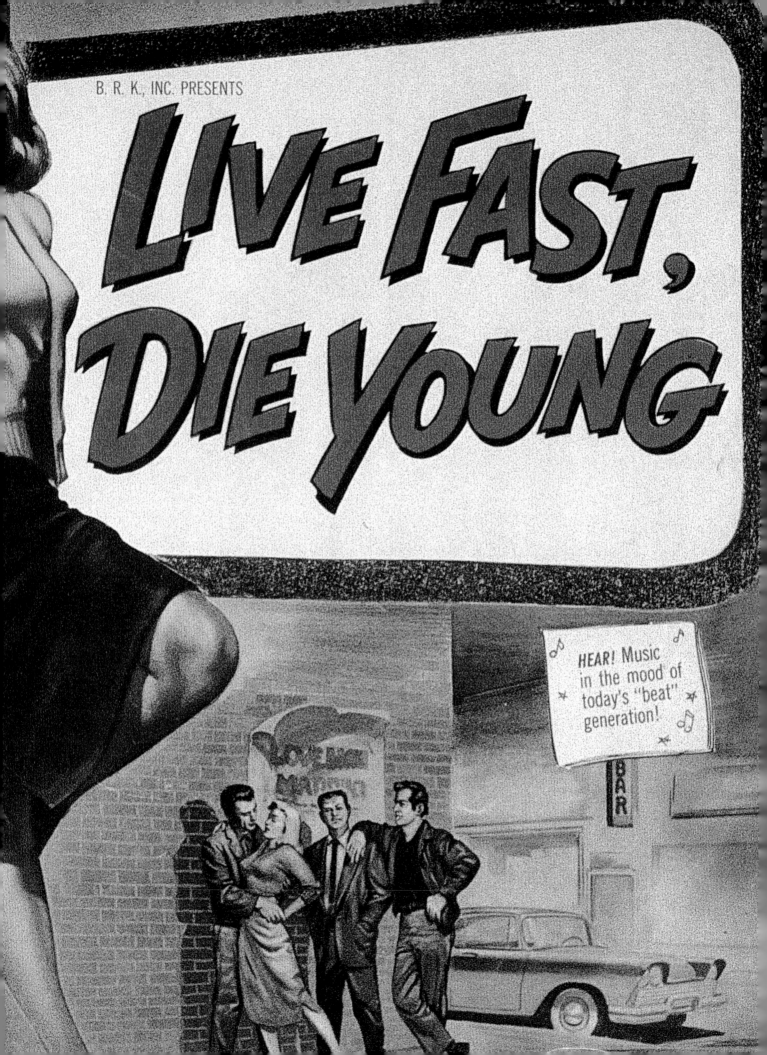

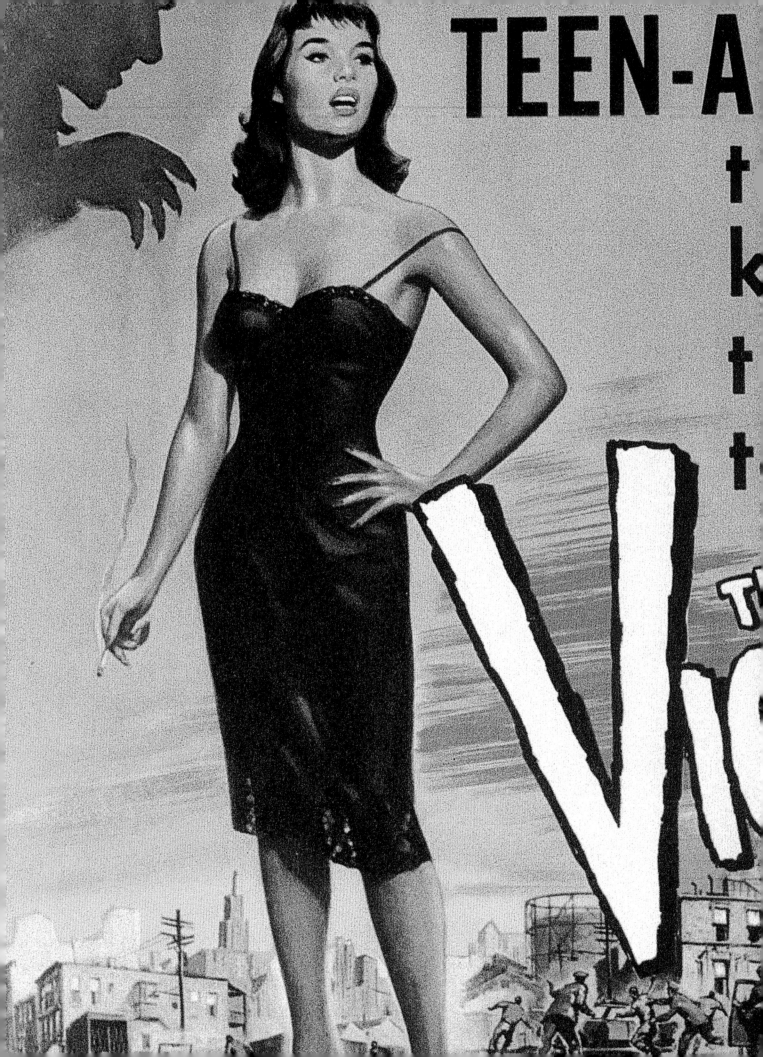

ERS ON PAROLE!

o young to
ow better...
o hard
care!

LATORS

ARTHUR
O'CONNELL

as The Probation
Officer!

THE ST
V

"Why am I
an outcast?...
shunned
by every
'decent'
citizen?"

"Why can a guy
get away with
anything in her
part of town?"

"She just looks
innocent.
But how does

STARRING J
CO-STARRING
LUANA PATTEN

AND

AN ILLUSTRATED HISTORY

MICHAEL BARSON
& STEVEN HELLER

Teenage

idential

CHRONICLE BOOKS ∗ SAN FRANCISCO

TO ADAM, BEN, AND DANNY BARSON, AND TO NICK HELLER—
ONE DAY SOON THEY WILL PROVIDE TEENAGE TERROR OF THEIR OWN.

ACKNOWLEDGMENTS

This book would not have been possible if not for the following collaborators. Thanks to Louise Fili for her splendid art direction, and Tonya Hudson at Louise Fili Ltd. for her design and production expertise. Our deep gratitude to Bill LeBlond, editor, Sarah Putman, associate editor, and Jill Jacobson, design coordinator at Chronicle Books.

For their contributions to this book our thanks to Rick Prelinger, Prelinger Archives, New York; Erich Rachlis, Archive Photos, New York. And for their support we thank Jean Behrend, David Feldman, Joseph Koch, Alan Levine, George Moonoogian, Debbie Simson Nicholson, Brian Rose, and Jean Tooter.

PHOTO CREDITS

Photographs on pages 13-17, 78-79, 118-121, and 129 courtesy of Archive Photos. *Seventeen* Magazine covers on pages 24 and 25 courtesy of *Seventeen* magazine. *Gasoline Alley* comic strips on pages 104 and 105 © Tribune Media Services, Inc. All Rights Reserved. Reprinted with permission. Film stills on pages 96 and 97 courtesy Prelinger Archives.

Table of Contents

KleenTeens Never

GOOD AND EVIL MAKE THEMSELVES EVIDENT IN REAL LIFE NOT AS ABSOLUTES, BUT AS GRADATIONS ALONG A VIRTUALLY INFINITE CONTINUUM. The American mass media, however, always has operated most comfortably when presenting clearly etched polarities to its consumers. So it has always been with the teenager in American pop culture. There are good teenagers and bad teenagers, and being just a little bit bad is rather like being just a little bit pregnant—in America, you are either pure as newfallen snow or you carry an indelible taint.

In the first half of the twentieth century, newspaper columnists and magazine cover stories fretted about the teenage gangs of the slums, the "wild boys of the road" who rode the rails and squatted in hobo jungles during the Depression years, and the middle-class kids who ran wild for want of adult supervision while their moms and dads were contributing to the war effort in the early forties. But at the same time, the doppleganger of the wayward youth—a kinder, gentler, *nicer* sort of American teenager who we will dub the KleenTeen—was being imagined, refined, and promoted by the popular arts.

Perhaps it all began with Booth Tarkington's novel *Seventeen*—published, appropriately enough, in the 'teens. A sensitive rendering of an adolescent boy's coming of age in a small midwestern town, it quickly earned its status as a must-read for those of like age. Beginning in the 1920s, a pair of high-schoolers starred in Franklin W. Dixon's juvenile adventure series *The Hardy Boys*. Brothers Frank and Joe Hardy helped to formulate the KleenTeen code as they heedlessly risked their lives (against the express wishes of their detective dad) and outwitted hardened

Die Young

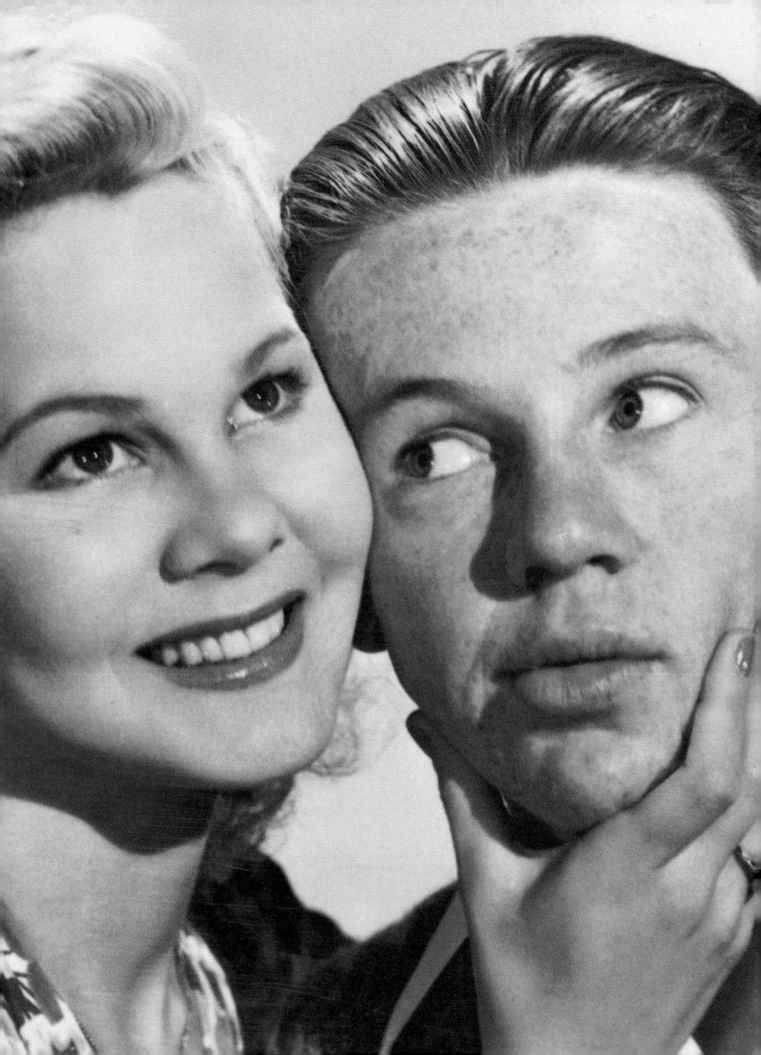

criminals without sneaking, or even desiring, so much as a single cigarette (let alone a sip of beer).

Nothing was bigger than the movies during the Depression, though, so it made sense that the first KleenTeen superstars of the thirties would emerge from the silver screen. Deanna Durbin was a cherubic songstress who had been signed by MGM at the age of fourteen, only to be dropped when the studio opted to build up Judy Garland instead. But it was Durbin who hit stardom first, signing with the floundering Universal studio and saving it almost single-handedly with a series of cheery pictures, beginning with *Three Smart Girls* in 1936 and continuing with the musicals *100 Men and a Girl* (1937), and *Mad About Music* and *That Certain Age* (both 1938). She and fellow teen star Mickey Rooney were honored with an Oscar in 1938 for "significant contributions in bringing to the screen the spirit and personification of youth." Her final films as a teenager were *Three Smart Girls Grow Up, First Love* (both 1939), *It's a Date* (1940), and *Spring Parade*; after 1940, she became just another talented grownup.

While Durbin was ascending to stardom, Mickey Rooney was being similarly groomed. In 1937, the MGM film *A Family Affair* featured a chipper teenage protagonist, Andy Hardy, and to play him, seventeen-year-old dynamo Mickey Rooney received the call. At the time he was basking in his unchallenged status as Hollywood's most incorrigible youth; unlike some other teenaged movie stars of the day, Rooney's KleenTeen characters wouldn't reflect his own real-life bent for hell-raising. The modest *A Family Affair* was intended as a one-shot release, but it struck a chord with audiences, and canny MGM immediately green-lighted production on a series about the clan—Andy, Mom and Judge Hardy, sister Marian, and dotty Aunt Millie—from small-town Carvel, USA.

Four low-budget, pleasantly inane entries were released in 1938 alone, including *Love Finds Andy Hardy*, in which teenaged Judy Garland vies for Andy's affections with his regular steady, Ann Rutherford, while sweater-girl Lana Turner roots them on. (That same year the brash Rooney jerked the tears of American moviegoers in *Boy's Town*, playing a juvenile delinquent transmuted into a good boy by the tough love of Spencer Tracy's Father Flanagan. Result: One honorary Oscar.) The crisis in an Andy Hardy yarn usually turned on the most frothy of contrivances: his crush on his high-school drama teacher in *Andy Hardy Gets Spring Fever*, or a plan to finance a new car by selling his old one to his pals, who naturally renege on paying him, in *Andy Hardy's Double Life*.

Ten Andy Hardy pictures were made between 1939 and 1946—WWII service interrupted Rooney's career for a few years—with Andy eventually going to college, now a young adult but still the victim of his hubris. By the time the series staggered to its inevitable close in 1946 with *Love Laughs at Andy Hardy*, Mickey Rooney was over the hill as America's favorite freckle-faced teenager. Indeed, having long since relinquished his 1939 crown as America's number-one box-office attraction (a pinnacle reached not only because of the Andy Hardy series,

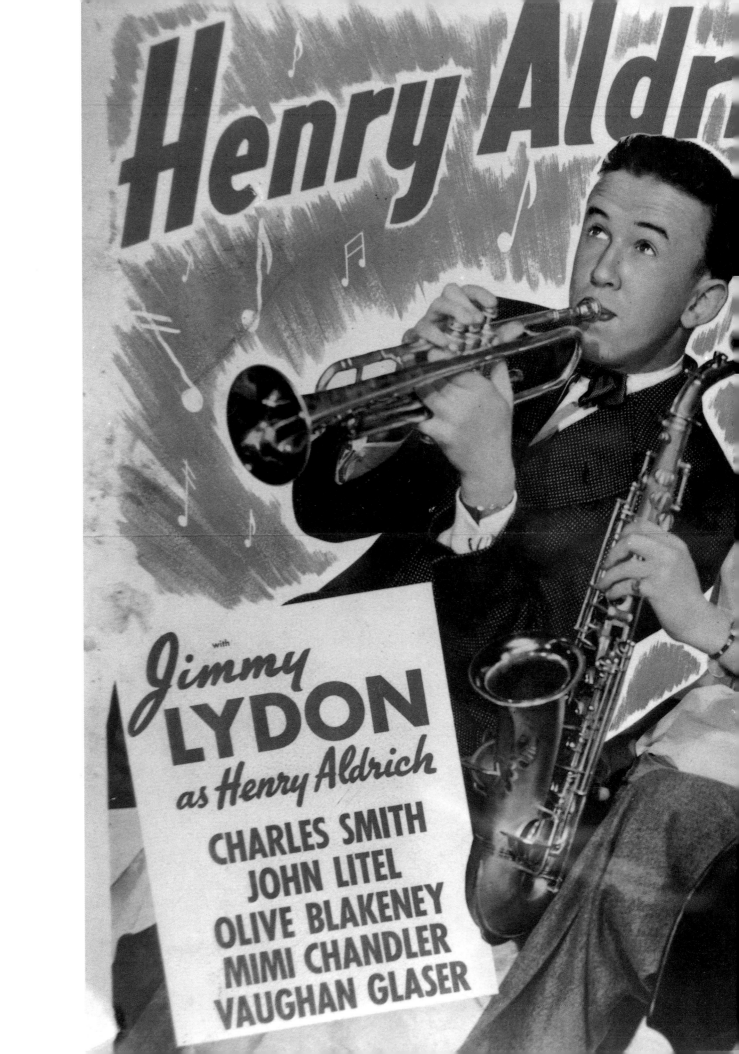

but also because of his musicals with Judy Garland, like *Babes in Arms*), Rooney eventually would have to struggle to find work even in B movies. So much for adulthood.

The success of the Andy Hardy pictures begat a number of imitations, one of the most successful being Paramount's Henry Aldrich movies. Based on a 1938 Broadway play by Clifford Goldsmith, which quickly had been adapted into a radio series, the first silver-screen entry was *What a Life!*, starring Jackie Cooper as the intrepid Henry. Cooper returned in 1941 in *Life with Henry*, but dropped out when Paramount decided to go head to head with MGM's Andy Hardy programmers. (In the meantime, he starred in a 1940 version of Tarkington's *Seventeen*, with Betty Field as his love interest.) The rather geeky Jimmy Lydon was cast in Cooper's stead and was the headliner in nine Aldrich pictures between 1941 and 1944, including *Henry Aldrich Swings It* and *Henry Aldrich Plays Cupid*.

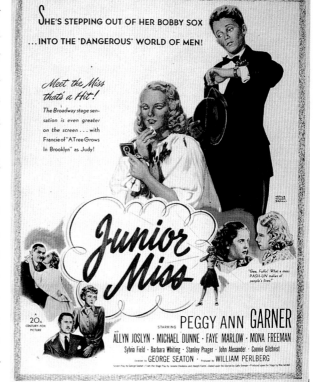

Shirley Temple—no longer the dimpled little girl in short dresses whom Depression audiences had doted on, but a KleenTeen in her own right—was chosen in 1942 to portray the comic strip heroine in *Miss Annie Rooney*, getting her first screen kiss from Dickie Moore in the bargain; but this erstwhile queen of the child stars never enjoyed comparable success as a teenaged performer (though she came close with the 1947 film *The Bachelor and the Bobby-Soxer*, opposite Cary Grant).

THE 1945 FILM **JUNIOR MISS** was advertised, logically enough, in the recently launched *Seventeen* magazine.

While Hollywood films were expanding exponentially to take advantage of the just-emerging, newly self-aware KleenTeen subculture, so too were America's other mass media gearing up to reach out to this potentially vast new audience. In September 1941, the publishers of *Parents Magazine* created the quintessential *Calling All Girls*, a relentlessly cheerful compendium of female KleenTeen concerns that billed itself as "The Modern Magazine for Girls and Sub-Debs." Early covers, which featured young stars like Shirley Temple and Gloria Warren, were bordered by descriptions of the cornucopia of delights to be found within: "Comics, Stories, Articles, Fashions, Etiquette, Cooking, Movies, Gadgets, Good Looks, and Junior Housekeeping."

Issue number thirteen (December 1942) offered comic-strip profiles of Lee Ya Ching, "China's #1 Aviatrix"; Liumila Pavlichenko, a sniper (!) in the Russian Army ("She Sticks to Her Guns"); and Marie Peary's "perilous journey through the land of ice and snow" to join her dad, Rear Admiral Peary. There was also a photo feature, "Solve Your Weightiest Problems with 'Chubby' Sizes," and regular departments "Susan Says," "Let's Talk Things Over," "Junior Housekeeping Department" (recipes for Thanksgiving), and "Winter Fun with Plants." Fiction by Nancy Drew creator Carolyn Keene rounded out the issue.

The advent of World War II created discipline problems for the thousands of

(opposite)
ERSTWHILE CHILD-STAR
SHIRLEY TEMPLE
was billed in this 1942 movie
as "queen of the teens"—
a bit of wishful thinking.

GLAMOUR GIRLS...
LOOK OUT !!!

KINEMATGRAPH WEE
August 6, 1942

Here comes Shirley!

Sensational Queen of the 'Teens.... in the brightest hit she's made!

Irresistible star booking . . . human story, delightful acting by Shirley Temple . . . big star values. KINEMATOGRAPH WEEKLY

EDWARD SMALL presents

SHIRLEY TEMPLE as
Miss Annie Rooney

WILLIAM **GARGAN** · GUY **KIBBEE** · DICKIE **MOORE**

Directed by EDWIN L. MARIN · Original Screenplay by GEORGE BRUCE

Shirley's First Love!

PROVINCIAL TRADE SHOWS

BIRMINGHAM	The Forum	August 11th	10.15 a.m.
LEEDS	Odeon	August 11th	10.15 a.m.
SHEFFIELD	Cinema House	August 12th	10.15 a.m.
LIVERPOOL	Paramount	August 14th	10.15 a.m.
MANCHESTER	Odeon	August 14th	10.15 a.m.
NEWCASTLE	Odeon	August 14th	10.15 a.m.
GLASGOW	Paramount	August 12th	10.15 a.m.

DISTRIBUTED BY

UNITED ARTISTS

CALLING ALL GIRLS

JULY 1946 10¢

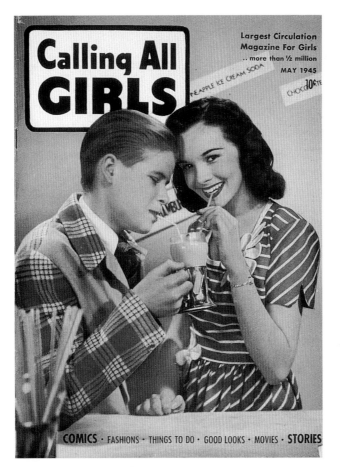

Calling All Girls, which debuted in 1941, became the first publication targeted expressly to teenage girls.

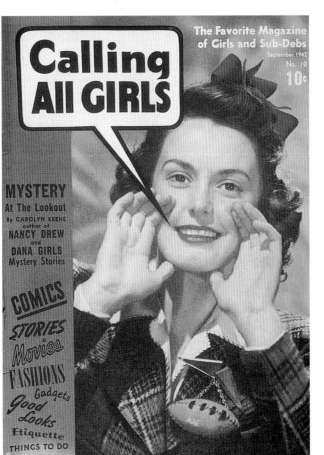

suddenly less-supervised youth on the home front, problems leading to a national outbreak of juvenile delinquency. But in a masterful display of bifurcated vision, the mass media were able both to acknowledge (and often sensationalize) America's new crisis with wayward youth while finding new ways to cover, celebrate, and serve its KleenTeen constituency. Following the runaway success of *Calling All Girls* (a success never really replicated by the company's half-hearted companion magazine *Calling All Boys*) came the visionary magazine *Seventeen*, which debuted with a 400,000-copy premiere issue in September 1944. The very title sent a clarion call to its target audience, a call that would not go unanswered.

The apotheosis of female KleenTeen culture, *Seventeen* was from the first the essence of good sense and a refined sensibility. "We expect you to run this show a lot more sensibly than we have," editor-in-chief Helen Valentine humbly admitted in the premiere issue. "You're going to have to run this show, so the sooner you start thinking about it, the better." As if anticipating the cynical statement made years later in a 1956 issue of *PTA Magazine*—"The trouble with teenagers began when some smart salesman made a group of them in order to sell bobby sox"—*Seventeen* was the perfect marriage between editorial content and naked (so to speak) commerce.

Consider the August 1945 issue, which presented advertisements for a dazzling array of KleenTeen products and speciality shops, including Filene's of Boston Hi-School Shop, Tabu (lipstick and perfume), TeenTown (purses), Flexnit (girdles and garter belts), Yardley (makeup), Younkers of Iowa ("Pandora" sweaters), Hudson's of Detroit (clothes), Teens by Coro (necklaces), The Hecht Co.'s Peggy Paige Teen Age Shop (clothes), Hi-Ho Juniors (cardigan suits), American Girl Shoes of Boston, Shusters of Milwaukee (clothes), The Young Circle Department of Saks Fifth Avenue, Dr. Pepper, Odo-Ro-No (deodorant), Perma-Lift Brassieres, Jane Irwill (sweaters), The Ernst Kern Co. of Detroit's High School Shop, TeenTimer Originals (clothes), Swan soap, Doris Dodsun of St. Louis (dresses), Kotex, and Mendoza Leopard Lapin (coats)—plus an ad for the movie *Junior Miss* with Peggy Ann Garner.

Dividing its editorial content into the sections titled "What You Wear," "Getting Along in the World," "Your Mind," "Having Fun," and "Fiction," that same issue offered the articles "Military Training—Should It Be Compulsory?", "Is Your Club a Secret Weapon?", "No for an Answer." The regular departments featured "Let's Go Shopping," "Teens in the News," and "Why Don't Parents Grow Up?" There were also articles on how to select hats, coats, sweaters, shoes, and party food. Advertisers quickly learned that there was no better vehicle for reaching that target audience, yet some manufacturers only began gearing up for the teen consumer after *Seventeen* proved that a viable, fairly affluent audience was out there waiting to be reached. Subsequent issues contained pieces like "How I Got My First Date," "Don't Starve, Don't Stuff," "Every Crowd Likes Pizza," "Your Young Emotions," "How to Win Men—and Influence Statistics," "Are You 'Unskinny'?", "Please—A Little Privacy," "The Versatile Egg," and "I

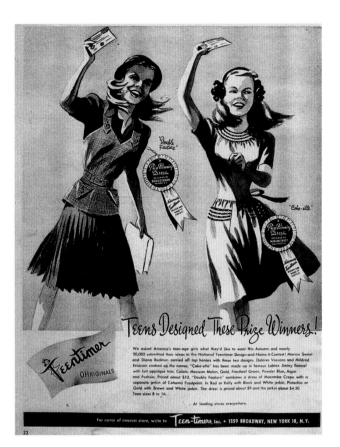

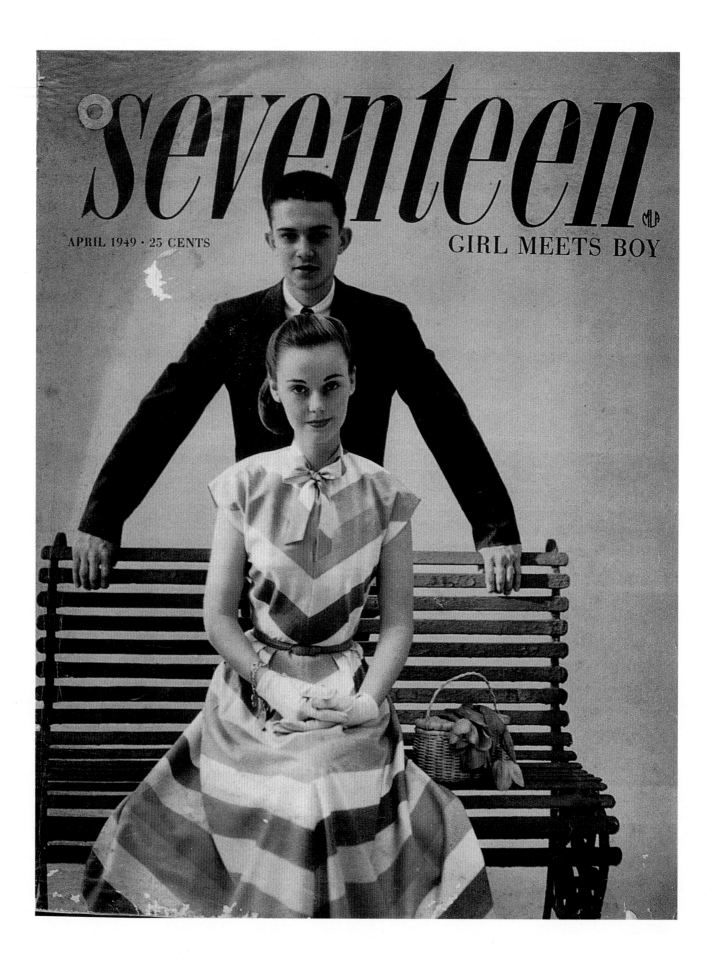

seventeen

APRIL 1949 · 25 CENTS

GIRL MEETS BOY

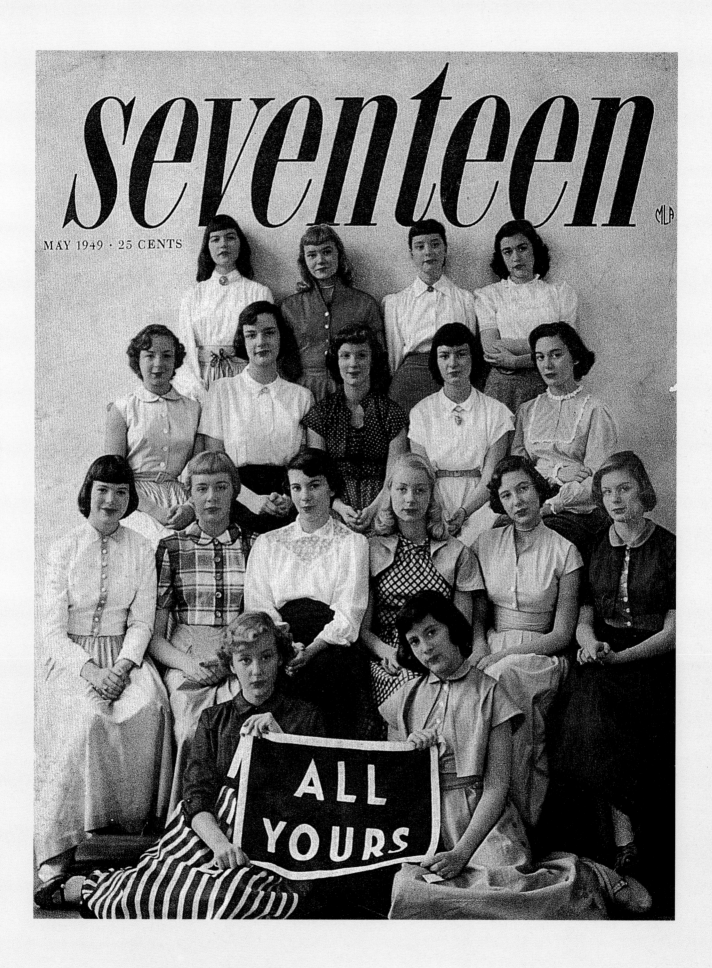

seventeen

MAY 1949 · 25 CENTS

ALL YOURS

Met Larry Parks." Once a year the magazine ran a special "It's All Yours" issue comprised of articles and features sent in by readers.

Over the years, the fashion ads and beauty products would change, with Tangee lipstick (sample tube available by sending in one thin dime!) eventually passing the torch to styles yet unborn. (Remember the white lipstick craze of the mid-sixties?) But for the KleenTeen girl, dating, diets, parties, and pizza would never go out of style. Neither would shopping, to the delight of the magazine's far flung advertisers. (And with $10 billion in discretionary income, according to a 1959 *Life* magazine article, teenagers could do a whole lot of shopping.) After *Seventeen*'s first issue sold out in a matter of days, the printings for subsequent issues were raised and raised again until circulation was well over the million mark. (With all of *Seventeen*'s consumer and lifestyle advice available each month, it was small wonder that KleenTeen girls were way, way ahead of the fellows, who had only *Esquire* and *True Detective* for guidance.)

While outbreaks of teen delinquency threatened many communities around the country throughout the 1940s, KleenTeens of good standing always could find a way to keep themselves occupied with wholesome activities. Some helped establish "Teen Town" outposts in rec centers, where dancing, music, and Pepsis could be enjoyed in a safe environment. During the war years, more than three thousand such clubs were opened, bearing evocative names like The Jive Hive and The Boogie Barn. The phenomenon was immortalized (sort of) in 1943 in the low-budget movie *Jive Junction*, in which Dickie Moore organized an all-girl swing band to star in his nightclub canteen for servicemen.

Life magazine reported in its December 20, 1948, cover story, "Teen-Age Fun," that sock hops—conceived to keep high school gym floors unscuffed—had been sighted in the Oklahoma City area, while slumber parties were beginning to be a fad in Atlanta. New York City kids could keep up by listening to WMCA's long-running radio show, "The High School Reporter," every night (except Sunday) at seven o'clock "for the latest news on high school sports and other extra curricular activities," featuring "a correspondent in every school." For teens who lived in the Philadelphia area, there was radio station WPEN, which in 1945 began broadcasting an early morning show called "Heigh-De-Ho"; it was "devoted entirely to chatty school news and sports." (It was actually an adaptation of the *Evening Bulletin*'s long-running daily column about, and by, teenagers.) The teenage boys of Des Moines had agreed to wear GI shoes to school every Tuesday, while Detroit cats were sporting "Boogie" haircuts—flat on top, long and slicked back on the sides.

Wild stuff, all right. But far, far wilder stuff was already happening in Detroit, Des Moines, Atlanta, and every American city in between. The Huns of juvenile delinquency were at the gates, and while KleenTeen culture would never really be in danger of subjugation, its sock hops, funny shoes, and slumber parties were about to enter a state of siege. For the JD simply wanted to take whatever he felt like taking; for starters, he took America's peace of mind.

(previous)
SEVENTEEN MAGAZINE
immediately became the bible
of female KleenTeen culture
following its 1944 debut. The
annual "All Yours" issue
offered editorial content
entirely written by readers.

(opposite)
WMCA'S "HIGH SCHOOL REPORTER"
was one of several radio programs
targeted to teens in major markets.

Tune in the

HIGH SCHOOL REPORTER

WMCA

AT 7 O'CLOCK EVERY EVENING.......
EXCEPT SUNDAY

THE PROGRAM THAT BRINGS YOU THE
LATEST NEWS ON HIGH SCHOOL SPORTS
& OTHER EXTRA CURRICULAR ACTIVITIES!
...A CORRESPONDENT IN EVERY SCHOOL

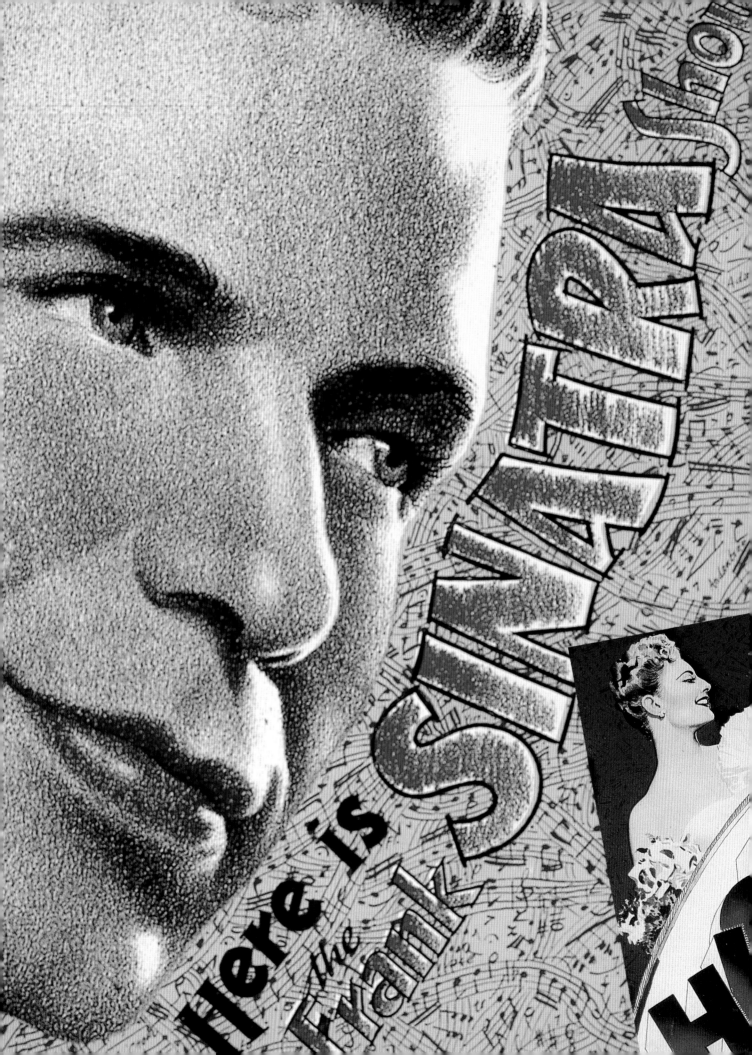

Forget the guy who sang "Something Stupid," made movies like *Tony Rome*, and hung around with the Rat Pack hitting on Vegas showgirls. It's the skinny kid from Hoboken, New Jersey we're talking about here. Frank Sinatra was already a star on the rise in 1939 when he fronted as the lead singer for Harry James's band, performing on the roof of New York's elegant Astor Hotel and on the Steel Pier in Atlantic City. A year later, on July 20, 1940, then the lead singer for Tommy Dorsey's Orchestra, Sinatra had the first number one hit to appear on *Billboard* magazine's newly conceived Music Popularity Chart—"I'll Never Smile Again." Already he was attracting huge crowds of teenage girls, bobby-soxers who swooned, screamed, and tore out their hair. "Sinatratics," some liked to be called; others preferred the term "Swoonatras." Frank himself favored "The Voice."

But Sinatra was propelled to utter superstardom only after he went solo in September 1942, breaking his contract with Dorsey in a bitter and prolonged dispute. His first major solo gig was at the Paramount in Times Square, and a near riot ensued. "I thought the goddamn building was going to cave in," recalled Benny Goodman, who also performed that night. "I never heard such commotion, with people rushing the stage." Sinatra's own recollection was of "Five thousand kids stamping, yelling, screaming, applauding— the sound that greeted me was absolutely deafening, a tremendous roar." The balcony almost fell down. Soon after, Sinatra was to appear at the Boston Armory; the management wisely took the precaution of bolting the seats to the floor.

Nineteen-year-old Jean Tooter and her sixteen-year-old sister Beverly [aka Aunt Jeanette and Mom to co-author M. Barson], of Washington, D.C., attended Sinatra's Watergate concert on the banks of the Potomac River one balmy day in 1942, and kindly shared their memories of the event with *Teenage Confidential!* "He was 'Frankie' in those days, not 'Sinatra' like now," recalled Jean Tooter. "His audience back then consisted primarily of swooning, screaming young ladies—the guys were mostly all in the service. Beverly and I went with my friend Betty; unlike us, she wasn't a true-blue, dyed-in-the-wool Sinatra fanatic. But her boyfriend, who was stationed at an army base in California, had recommended that she see Sinatra if she had a chance. Well, after several songs, Betty was a convert. She was cheering, applauding, and emitting this shrill, penetrating whistle, thus outdoing even us Tooter sisters in enthusiasm. I recently asked Betty if she remembered the concert, and she said, 'Do I?! I screamed like a crazy teenager.' 'We all did,' I told her."

The comic-book apotheosis of forties KleenTeen culture surely must have been embodied in the red-headed, bow-tied, saddle-shoed form of Archie Andrews, the girl-obsessed teen who debuted in the pages of *Pep Comics* in the December 1941 issue. The Puckish Archie earned his own comic book a year later, and by 1946 he could claim his own newspaper comic strip, an NBC radio series every Wednesday night, and regular monthly appearances in a plethora of comic books, including *Archie* ("America's Top Teenager"), *Laugh*, and *Pep*. Those comic books would be joined over the next few years by *Archie's Pal Jughead*, *Archie's Girls Betty and Veronica*, *Archie's Rival Reggie*, and so on and so on, until a beachhead—nay, an empire!—of Kleen-Teendom had been established once and forevermore. By 1949, *Archie Comics* (subtitled "The Mirth of a Nation") was selling two million copies a month, earning it the title of "America's best-selling comic book."

One of the strip's basic conceits is that Archie drools over the raven-tressed Veronica while brushing off the infatuated blonde Betty, even though the curvaceous girls are identical in every respect except for the color of their hair. (In 1954, the twelfth issue of *Mad* offered the wicked lampoon "Starchie," taking the strip's inane innocence and turning it on its head by having Archie and his pals 'n' gals transformed into a gang of brutal juvenile delinquents.)

The founding father of this Everyman of adolescence was Bob Montana, an uprooted Californian whose family moved to the New England mill town of Haverhill, Massachusetts, in the mid-1930s. When Montana was a teenager attending Haverhill High in the late 1930s, he surely had sampled the Andy Hardy and Henry Aldrich movies. But he hardly needed to rely on Hollywood to weave the warp and woof of mythical Riverdale High and its teenage hero, Archie Andrews; he had just lived it. "Everything that happened to Archie happened to me, except that Archie always gets out of it," Montana once remarked in an interview. He developed his ageless alter ego while contributing sketches to the high school paper, *The Brown and Gold*, and based many of the strip's zany characters on his fellow students and contemporary faculty members. The long-suffering, blonde-pony-tailed Betty Cooper was inspired by one of Montana's ex-girlfriends, Jughead by a kid known to the locals as "Skinny," and the rotund Mr. Weatherbee by Haverhill High's then-principal. The va-va-voom-y Veronica was a synthesis of various cinema bombshells, while Archie appeared to be a cross between the young Mickey Rooney and Montana himself—they were both born in 1920. As for the kids' primary hangout, The Chocklit Shop was a clone of Haverhill's Chocolate Shop on Merrimac Street, where Montana often sat and sketched for the amusement of his pals. And the replica of Rodin's "The Thinker" pondering life in front of Riverdale High was most familiar to the students who passed it by every day as they entered the original Haverhill High.

The "Archie" phenomenon soon inspired a horde of imitation comic books, each featuring a reasonable facsimile of "America's Favorite Teen," with dating and hanging out after school the endlessly recurring theme. The MLJ company itself was quick to capitalize, introducing a clone named "Wilbur" (innovation: a blond crewcut and a black sweater bearing a big white "W" on his chest) and a female counterpart, "Suzi," both in the pages of *Top-Notch Laugh Comics*.

For the many other comic book publishers, this newly planted orchard was ripe for harvesting. Soon there was *Oscar Comics*, and *Meet Merton*. There was *Leave It to Binky*. There was *Vicki Comics*. There was *Teena*, and there was *Cindy*. The old newspaper strip *Freckles and His Friends* suddenly was reprinted in comic book form. And in 1947, the superhero title *All Winners* was converted into *All Teen Comics*, then abbreviated to just *Teen*; it featured the likes of "Georgie," "Mitzi," "Cindy," and "Patsy Walker," most of whom were quickly spun off into their own monthly books.

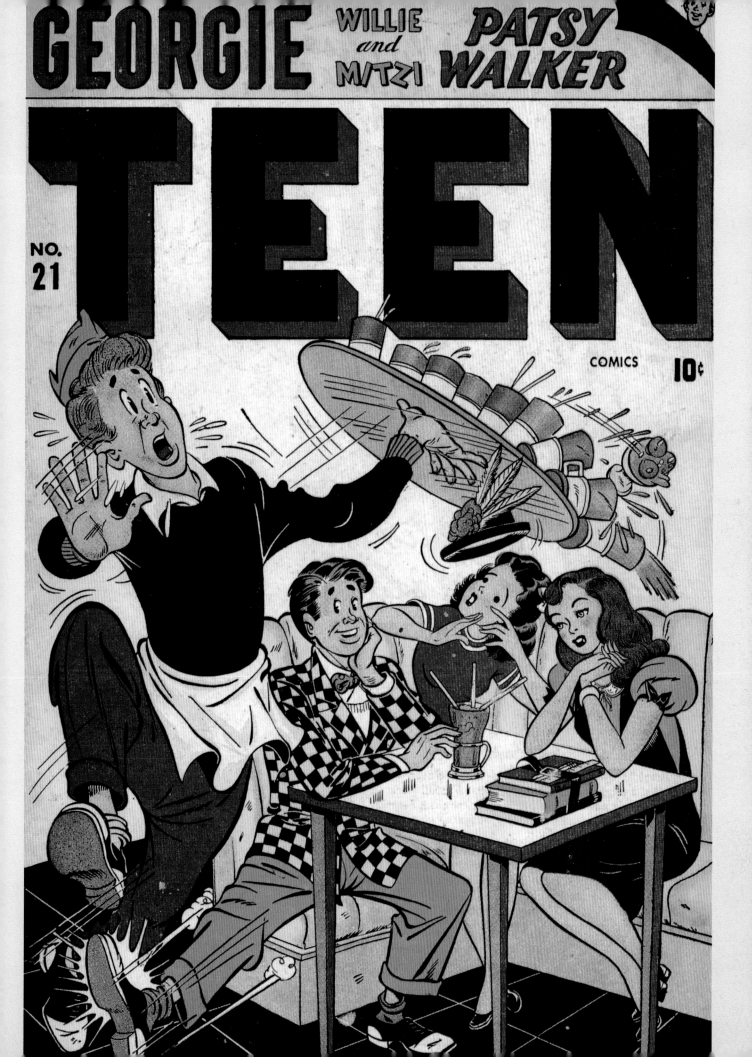

"D" is for

FOR AS LONG AS THERE HAVE BEEN KIDS, THERE HAVE BEEN BAD KIDS. BUT IT TOOK THE EMERGENCE OF A DISTINCTLY TEEN CULTURE TO ENABLE THE TRULY ROTTEN fruit of youth to fall off the tree en masse, and in numbers there is danger. Even before the dawn of this century, gangs of teenagers had plagued New York City and other major metropolitan centers, committing violent crimes with all the single-minded viciousness of the adult hoodlums they emulated. Those marauding adolescents were really just gangsters-in-training, biding their time until accepted into the adult society of criminals; they were kid criminals existing outside of a kid code and kid culture.

Reports of troubled kids making trouble had been a favorite subject for the media even before the Jazz Age debaucheries of the early twenties. In the 1944 *Liberty* magazine article "Youth Has Flamed Before," Edith M. Stern reassured her readers that the recent headlines about increases in juvenile delinquency were nothing new to America, citing complaints dating from 1770 about preventing unmarried couples from "irregular night walking, frolicking and keeping bad company," and from the 1870s about youths going on horseback rides unchaperoned.

In 1918, Cincinnati reported an increase in juvenile delinquency of twenty-one percent. "An ugly sinister wave of immorality is sweeping over the country," one clergyman complained. The sensational social critique *The Revolt of Modern Youth* by Judge Ben B. Lindsay was published in 1925; it complained of a youth culture "whose ways, customs, purposes, vision, and modes of thought were as unknown to her parents and teachers as the social customs of Mars." The Joan

Delinquent

Crawford movie *Our Dancing Daughters* (1928) was about children of privilege acting up and acting out, as were F. Scott Fitzgerald's novel *This Side of Paradise*, Percy Marks's *The Plastic Age*, and Warner Fabian's *Flaming Youth*.

But it took the Great Depression to bring the underage underclass to the forefront of America's consciousness. Headlines were echoed in William Wellman's 1933 film *Wild Boys of the Road*, the ur-movie about juvenile deliquency. In this gritty Warner Bros.' problem pic, teens Frankie Darrow and Edwin Phillips find themselves up against hard times when their dads lose

GIRLS UNDER 21 was among the first of the many 1940s B-pictures that capitalized on headlines about wayward teens.

their jobs. Unable to find work, they begin to ride the rails looking for employment; of course, there's none to be found. The fellows save comely hard-luck lasses Rochelle Hudson and Dorothy Coonan from a rapacious brakeman, and the girls then join them on their travels. The kids finally end up in court, arrested for petty larceny, and draw a pie-in-the-sky lecture from a judge who obviously voted for FDR.

But moviegoers of the thirties had enough bad news without spending their scheckels on tales about hard-luck kids, preferring to watch such KleenTeen avatars as Deanna Durbin (*Three Smart Girls, First Love*), Mickey Rooney, Judy Garland, and Jane Withers (*High School, Youth Will Be Served*). Then there was the comically criminal Dead End Kids (aka The East Side Kids, aka The Bowery Boys), who were introduced as supporting characters in the 1937 film of the Broadway play *Dead End*, and continued in quasi-social-problem vehicles like *Crime School* (1938) and *Hell's Kitchen* (1939) before earning their own interminable series of comedic B pictures. (They were still "Boys" well into the 1950s, when some of them could have been grandads.)

Even after the end of the Depression, second- and third-tier studios like Columbia, PRC, and Monogram continued to plumb the tabloids for stories about wayward youth. Low-budget films like the 1938 quartet *Girls on Probation*, *Delinquent Parents*, *Juvenile Court*, and *Rebellious Daughters* were followed by "problem" pics like the 1940 *Girls of the Road* and *Girls Under 21*. Perhaps those darker visions of teen life were inspired, at least in part, by the book *Designs in Scarlet* by Courtney Ryley Cooper. First published in 1939, it carried the blurbs, "Written in cooperation with the F.B.I. and other law-enforcement agencies" and "A frank and challenging expose of the excesses of modern youth"; it went through five printings before the year was out. The *New York Times* described it as "Terrifying....Based on first-hand research, this book is disturbing to any reader, but to parents of children in their teens it is likely to carry terrifying implications."

Those implications began to be realized with the advent of World War II. The exodus of parents from the home—dads to train and fight, moms to work in offices and factories to help the war effort and make ends meet—had lit a low flame under the kettle of teen culture; underneath the lid, bubbling noises were now being heard. *Click* magazine, a low-budget version of *Life* and *Look*, ran an article in its March 1943 issue entitled "Parents Are on the Spot!" It warned, "Wartime delinquency must be stopped...Startling data recently released by the New York State Board of Social Welfare reveals the incredible increase in war problem children throughout the nation. Juvenile delinquency is up 22 per cent and...your youngsters, like these, may be hard-hit by a disrupted home life." The following month, *Click* ran a lengthy story promoted on the cover as "Face the Facts on Kid Criminals," which argued that a serious gap lay between the bobby-sox brigade's harmless consumption of Andy Hardy movies and Frank Sinatra records and what was actually taking place with unsupervised (or at least under-supervised) youth in wartime America.

Click's investigation opened with a charming photo gallery of teen thugs, including the Massachusetts boy and girl who murdered a New Beford man for a haul of forty-eight cents. The piece then set its sights on the delinquency problems besetting Hartford, Connecticut:

> War unleashes powerful social and psychological forces. Symptomatic of these is the 21 per cent nation-wide increase in juvenile delinquency reported in 1942's first nine months by FBI Director J. Edgar Hoover. Yet it has only been recently that delinquency has been recognized as an important war problem on the home front....With fathers changing from job to job, mothers either going to work or going crazy in an effort to carry on family life with all normal schedules wrecked by unprecedented work hours, children left to roam the streets, it was inevitable that Hartford's delinquency would increase.

TWO MORE LOW-BUDGET FILMS
that showed the day's reckless youth
engaging in wanton foolishness.

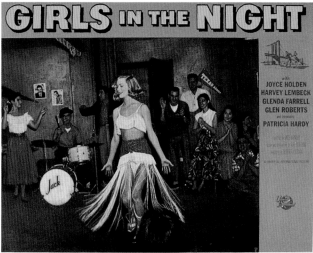

YOUTH GIRLS MISSI
YOUNG GIRLS CRIME
INCREASE IN YOUTHFU
YOUNG THRILL SEEKE JUVENILE CR GANGS
YOU DANGER TO

FIRST FRANK STORY of WAYWARD YOUTH

WHERE ARE YOU

Thrilling Timely... PACKED *with* SUSPENSE!

MONOGRAM SPECIAL DISTRIBU

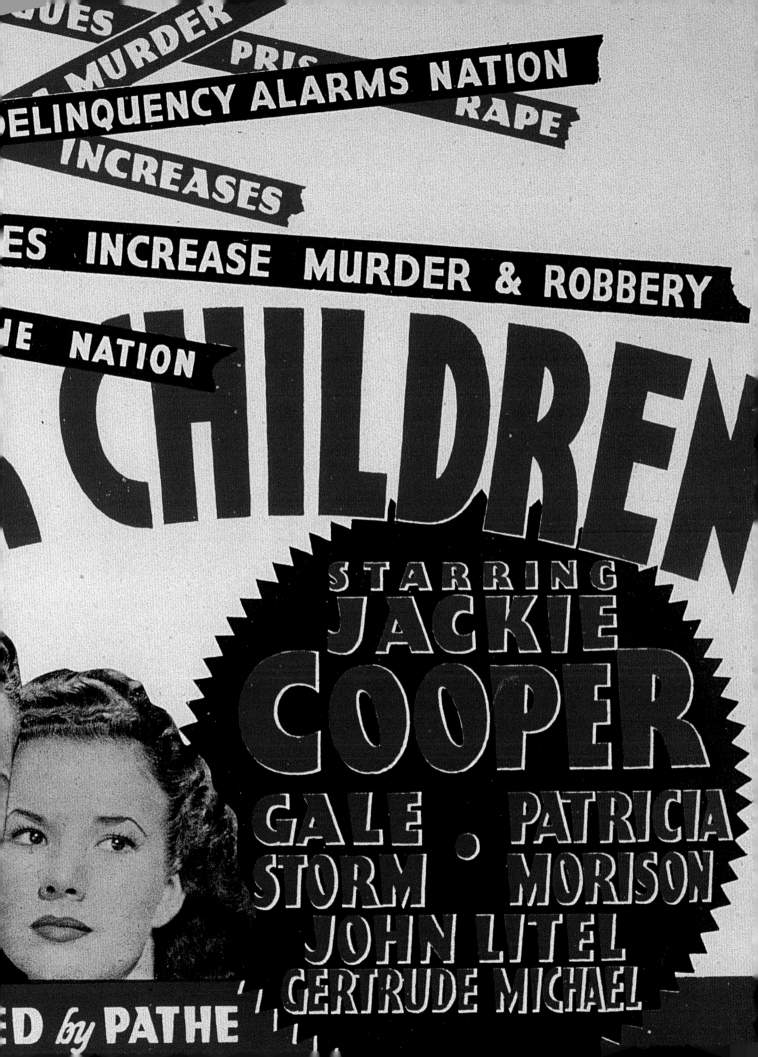

The article goes on to show how the city of Hartford responded to those problems, with the Park Department and the Council of Social Agencies teaming up to create community houses and programs that kept the city's teens productively occupied.

Not to be outdone, *Pic* magazine offered the one-two punch of "Teen-Age Vice" in its July 6, 1943 number, followed by "Boston's Morals Problem" in its issue of August 17, 1943. The first article was pegged to the arrest of seventeen-year-old Josephine Tencza, who was charged (unjustly, the article maintained) with employing twelve- to fourteen-year-old girls "to entertain middle-aged men in lurid sex orgies." The piece went on to warn that "Teen-age vice has become one of our most perplexing and ghastly social problems." The August 17 story, written by David Brown, took as its focus "Boston's bad girls," headlining the fact that "Boston's juvenile delinquency is worse today than ever." Brown illustrated that thesis with statistics: "Since last year there has been a forty-percent increase in the number of girls brought up before Boston's Juvenile Court. Sex offenses involving teen-age girls are up 200 percent. The average age of offenders is fifteen. The number of runaway girls is up 48 percent over 1942. Truancy cases are up 400 percent."

Cases of venereal disease among teens were also sky-high, the article pointed out. Photos accompanying the piece include one that shows a girl making out with a serviceman on Boston Common—"the favorite meeting place of teen-age girls and men in uniform." The writer urged that Boston take a tip from the town of Covington, Kentucky, which had recently passed an ordinance fining parents from one to fifty dollars if their teenagers were found wandering the streets after 10:30 P.M.

Equally alarming, if not more so, was an extended investigation that ran in *Look* magazine's September 21 issue entitled "Are These Our Children?" Here the flash point is Radford, Virginia, which had come together—adults working hand-in-hand with kids—to conquer "America's gravest community problem." (As was the case with *Click*'s stories about wayward kids, this town's struggles were intended to be taken as emblematic of Everytown, USA.) The piece begins ominously, and goes down from there:

> You see it in the papers every day....Five boys caught stealing automobiles; a 15-year-old girl charged with thirty sex offenses; in Detroit, a juvenile mob invades night clubs, bars, movies, smashing windows and furniture; a father reproves his 17-year-old son, and the next day the father's mutilated body is found beside a railroad track. J. Edgar Hoover reports 1942 arrests for drunkenness of girls under 21 up 40 per cent over 1941, for prostitution 64 per cent, other sex offenses, 104 per cent ... with 1943 arrests mounting. *Are these our children?*

The article makes the point—none too subtly—that "As boys, they deserve sympathy; as symbols, they deserve alarm," and goes on to identify the root causes of their crimes against society: "Broken homes, irresponsible parents, crowded

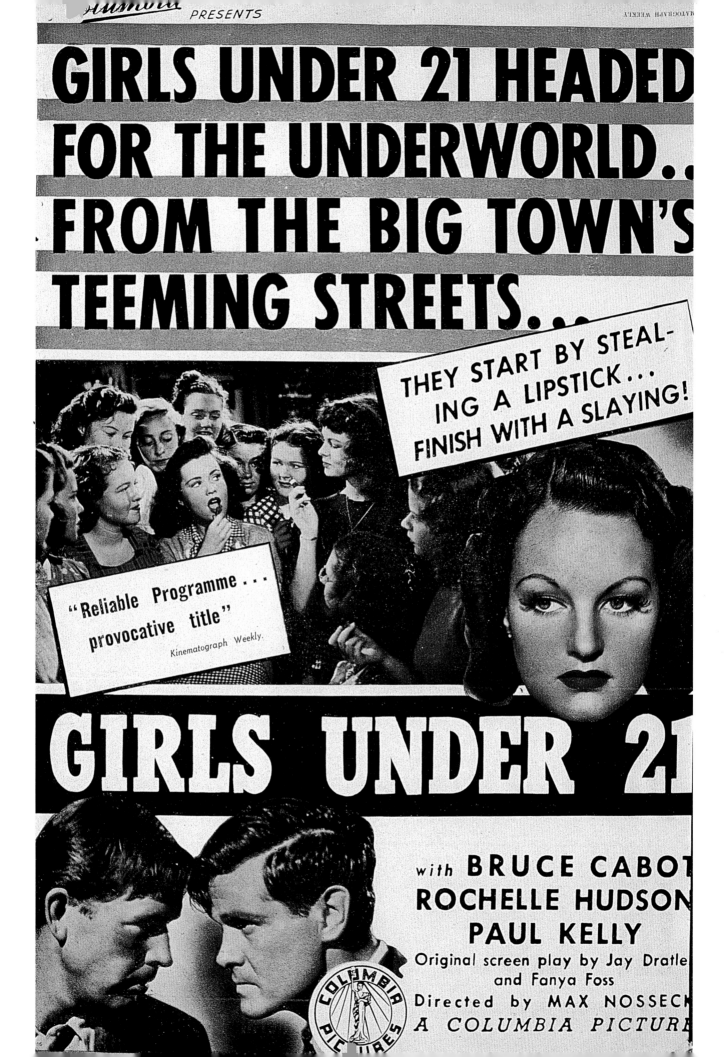

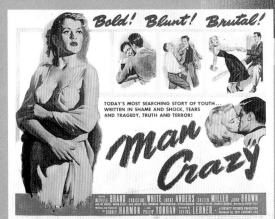

THE PROTO-PROBLEM PICS

Delinquent Parents and
Juvenile Court were both
released in 1938, as the Great
Depression was winding down.

MAN CRAZY

was one of several low-budget films
about juvenile delinquency to appear
in 1953; others that year included
Girls in the Night, *Problem Girls*, and
the British release *The Slasher*

schools, unsupervised play, bad housing: these leave youth a prey to evil, their priceless energy unharnessed." *Look*'s photo-essay provides us with the test case of Bill, who stole and wrecked a bicycle, and takes us through Radford's enlightened juvenile court system step by step, until we find the lad happily rehabilitated.

Reaction to the piece was so pronounced that just two weeks later *Look* surveyed "six prominent Americans," including Eleanor Roosevelt, chief Boy Scout executive Elbert K. Fretwell, and Justice Justine Wise Polier, of New York City's Domestic Relations Court, asking them for their response to the challenge, "Are These Our Children?" Most of the expert commentators blamed the parents and the malaise of the war for the delinquency of their kids; as Dr. Hugh Chaplin argued, "It is not mostly the fault of the children themselves, but of the times in which they live and the immediate influence of their surroundings."

On the next page of that October 5, 1943 issue of *Look* is a letter from RKO Studios vice president of production Charles W. Koerner asking the magazine to sell the rights to the story to RKO so it can be turned into a movie. And RKO did film it—quite loosely—as *Youth Runs Wild*, starring Bonita Granville as the primary victim of her parents' absenteeism. "What Happens to These Unguarded Youngsters? The Truth about Modern Youth!" was one of the come-ons for the film. This expose of kids gone astray became just one of many torn-from-the-headlines movies released in 1944 by studios eager to tap into the day's panicky zeitgeist. The ever-resourceful Monogram had already issued a pair of juvenile delinquency melodramas in 1943, *Are These Our Parents?* and *Where Are Your Children?*, that were thinly disguised, quickly produced echoes of the *Look* article (the latter picture featured former child-star Jackie Cooper). Monogram followed those with the tawdry reformatory drama *Girls of the Big House*. PRC checked in with the equally exploitative *I Accuse My Parents* (nothing like passing the buck!) and *Delinquent Daughters*—"Teensters headed for perdition," the campaign manual blared, "Youth Running Wild! Unheeded! Unchecked!" There was even a road-show exploitation picture called *Teen Age* that tried (on a budget of $21.95) to cash in on the hullabaloo.

In 1943, no less an authority than J. Edgar Hoover warned America that "This country is in deadly peril. A creeping rot of moral disintegration is eating into our nation." Of course, some teenagers—the KleenTeens—rejected the wild ways of some of their peers and fought back, trying to keep America pure. Teenager Ruth Clifton was the editor of the Moline, Illinois, high school paper in 1943 when she decided to lead a crusade to keep teenagers from drinking and gambling in saloons—a favorite pastime in wide-open Moline. Clifton organized six hundred of her classmates to petition the city council to build a rec center for the town's idle youth. An empty warehouse was commandeered and renovated, and soon fourteen hundred kids were dancing and drinking Cokes instead of smoking and getting drunk. Clifton told her story in the inspirational *Look* magazine article, "Youth Can Solve Its Own Problems" (May 16, 1944), which

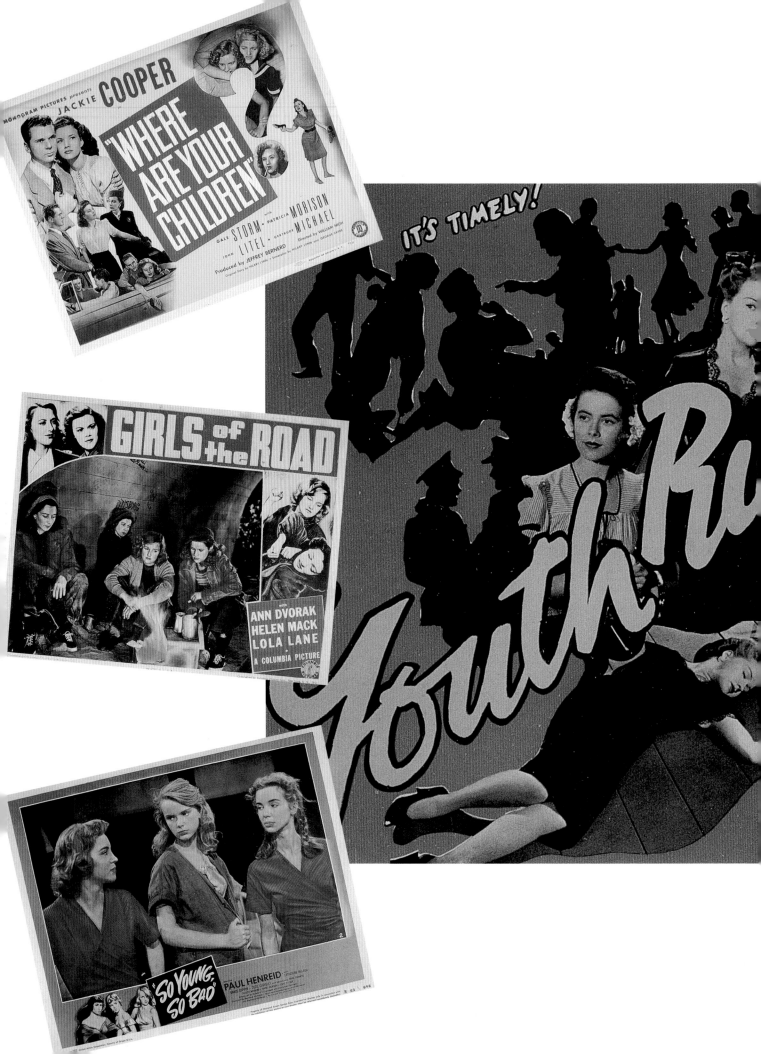

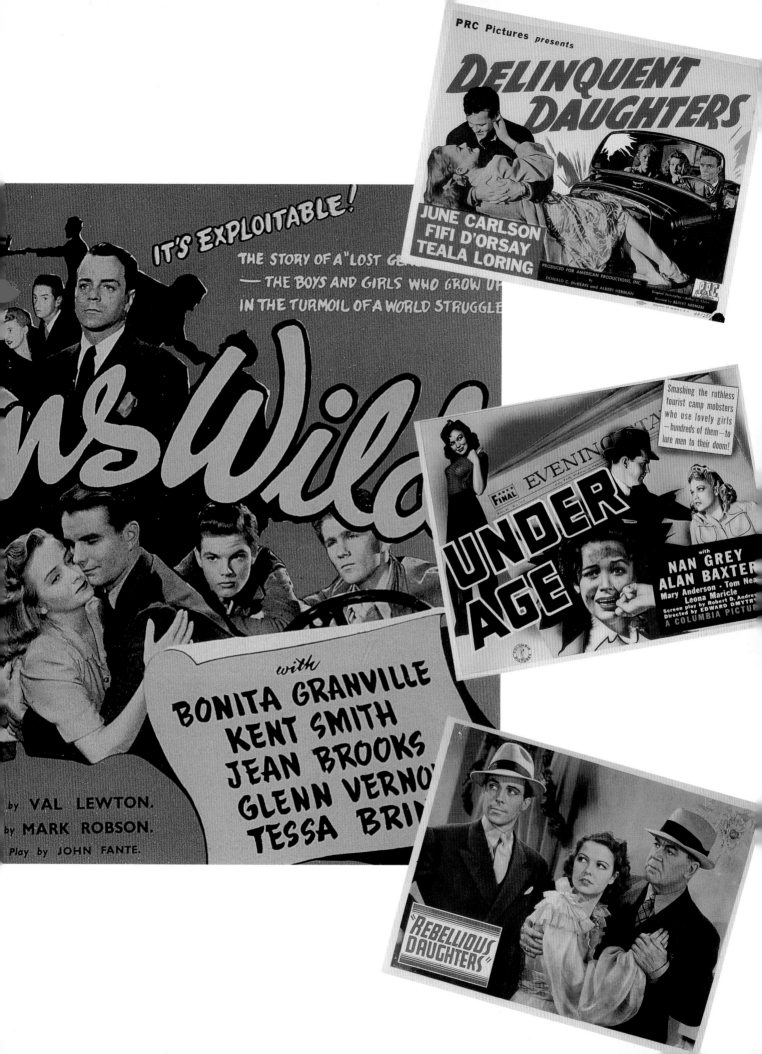

proudly claimed that "This story shows how juvenile delinquency can be decreased by mobilization of the energies and creativeness of young people.... Young America knows its own difficulties; it will solve them, given a chance."

But would it? Could it?

Once the war ended, parents returned to their homes, but things could never again be quite as they were. Teens had tasted the freedom of a less-supervised life while dads fought overseas and moms toiled in the workplace, and the taste was sweet. Having had several years to bond with their peers and create their own private culture, teens were hardly inclined to give back the territory they had gained. They considered it the spoils of war.

This burgeoning teenage subculture was fertile territory for novelists, and shortly after the war the problems that had led America into a state of near panic began to be digested and transformed into fiction. The first wave of those post-war novels focusing on problem youth (as opposed to the problems *of* youth) included Irving Shulman's *The Amboy Dukes*, a sensational, brutally candid account of life in a Brooklyn gang; Lenard Kaufman's *The Lower Part of the Sky*, and Willard Motley's *Knock on Any Door*. *The Amboy Dukes*, published in hardcover in 1947, was one of the first naturalistic novels to offer an unblinking portrait of the teen gang—"A staggering picture of what goes on in slum sections of big cities when parents are too indifferent," gushed the *Philadelphia Sunday Bulletin*. Before his protagonists come to their inevitable bad end, Shulman makes much of their hard-boiled camaraderie and easily available women, no doubt glamorizing the JD image for untold numbers of envious suburban teens.

The Lower Part of the Sky, published in 1948 and reissued in paperback in 1952 with the less poetic (but more apt) title *Juvenile Delinquents*, was described by the publisher as "the raw, unflinching story of three kids from the slums and how they learned to steal, assault, and kill." The 1947 *Knock on Any Door* tells the story of an idealistic attorney who tries to save the bacon of slum-raised teenager Nick Romano, a career criminal who committed a murder; Morton employs the old nature vs. nurture argument to enlist the sympathy of the jury, although we eventually learn that Romano isn't worth saving.

The Amboy Dukes was made into a pallid, low-budget quickie by Universal in 1949, bearing the wimpy title *City Across the River*, while the preachy *Knock*

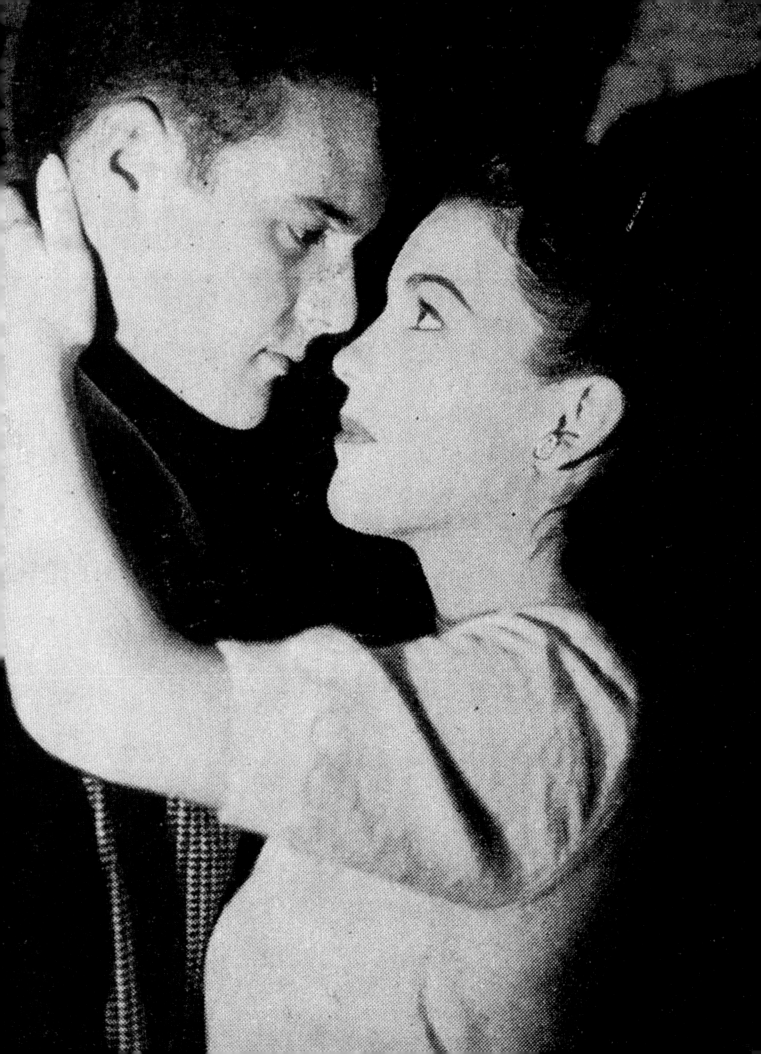

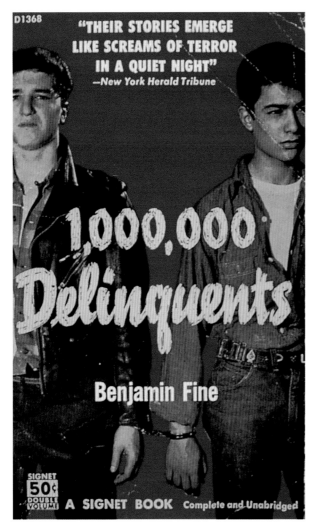

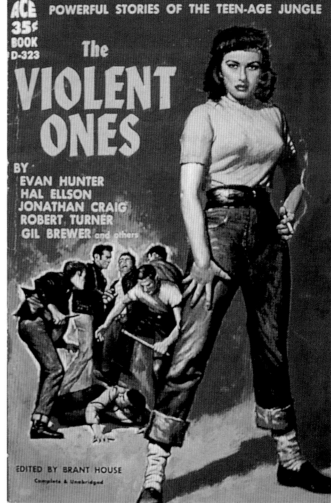

PAPERBACK BOOKS
became a wildly popular vehicle
for spreading the word about
America's newest threat: "the
bitter poison of delinquency."

on Any Door got the A treatment that same year, with Humphrey Bogart starring as the attorney and newcomer John Derek as the callow sociopath Romano. Far better than either was Nicholas Ray's 1949 noir *They Live by Night*, a remake of Edward Anderson's 1937 novel *Thieves Like Us*; Farley Granger and Cathy O'Donnell were most sympathetic as teen lovers who become fatally entwined with a gang of adult criminals. And there were still more JD problem pics

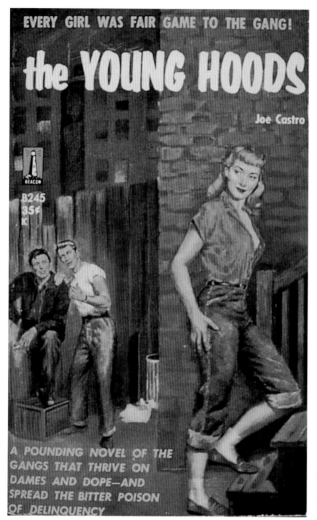

released in 1949—*Bad Boy* with Audie Murphy ("Who put the gun in his hand?"), *Johnny Holiday, Flame of Youth*, and *Not Wanted*, a teen pregnancy drama cowritten and codirected by Ida Lupino.

The Amboy Dukes would go on to sell two million copies (mostly in paperback) over the next several years, its grassroots success helping to give birth to an entire genre of JD fiction—one that was not only *about*, but also targeted *to*, the teen audience. One of its most adept practioners was Brooklyn writer Hal Ellson, whose 1949 *Duke* was billed as "a realistic novel" about a teen ganglord in Harlem "that will both shock and awaken you." The paperback edition went through four printings in the first six months of 1950, leading to the quick publication that same year of Ellson's *Tomboy*, "A Shocking Novel of Teen-Age Gang Life in the Slums of Manhattan" with an adolescent ganggirl as its protagonist. (An enthusiastic introduction by "the noted psychiatrist" Dr. Fredric Wertham adorned the package.) Ellson's speciality was the interior monologue which he convincingly filtered through the mind of a fifteen-year-old thug; he went on to publish a dozen novels in a similar vein throughout the decade, including *Rock, Stairway to Nowhere, I Take What I Want, The Golden Spike, Jailbait Street, A Nest of Fear, Tell Them Nothing, This Is It*, and *I'll Fix You*. In Ellson's wake would come such garish paperback original yarns as *Rumble in the Housing Project, Go Man Go, The Young Wolves, Run Chico Run, The Thrill Kids, Play It Cool, Teen-Age Mafia*, and Harlan Ellison's *Rumble* and *The Juvies*.

With the boom in JD literature in full swing by 1950, publishers began dusting off their backlist. In 1952, old-timer Benjamin Appel found his 1930s short stories published as a collection entitled *Hell's Kitchen*, while the 1939 nonfiction hit *Designs in Scarlet* was revised and reissued in 1952 with the snazzy title *Teen-Age Vice*. In the meantime, more hard-hitting journalism about the JD problem was being published in book form. *Jailbait* by William Bernard had been issued by a small press in 1949, but in its 1951 Popular Library paperback edition this "real story of teen-age sin the headlines have never dared reveal" went on to

become a bestseller. (It would later come out that William Bernard was really a woman named Meta F. Williams, a former worker with underprivileged children from the New York Board of Education.)

Dale Kramer and Madeline Carr's 1953 study *Teen-Age Gangs* came with an introduction by Senator Estes Kefauver, who notes ominously, "FBI director J. Edgar Hoover has revealed that more persons eighteen years old were arrested last year than any other age group." There was also David Hulburd's grim *H Is for Heroin* (1953), expanded from his 1952 *Woman's Home Companion* article "It Happened to Amy," about a seventeen-year-old girl who develops an addiction to heroin under her parents' noses. The December 1954 issue of *Inside* magazine posed the question, "Do the Courts Coddle Our Delinquents?" The answer by now should come as no surprise: "Juvenile Delinquency has increased by 30 per cent in the last four years....Many authorities feel the courts have been coddling these midget mobsters."

Even the confession magazines were getting into the act, with "authentic" first-person tales of teen woe like this six-pack from *True Story*: "We Were High School Thrill Chasers" (December 1952); "We Were Truant Teens—On the Loose, and Ripe for Trouble!" (April 1954); "They Called Us High School Hoodlums" (July 1954); "Runaway Teenagers" (April 1955); "Gang Delinquent," purportedly an interview with a fifteen-year-old named Pete Bender, then an inmate of the Berkshire Industrial Farm in Canaan, New York (January 1956); and "Teenage Bottle Party" (November 1955), which begins, "None of us had ever been in trouble before. That's why it shocked people so much when it came out in the newspapers. They felt that if we—kids from good homes, with good reputations—could bring tragedy and disgrace upon ourselves, no teenager could be trusted."

America was leaning more and more to the same conclusion. If it wasn't just slum kids making all the problems—if "kids from good homes" were also becoming newspaper headlines—then no one could be trusted, and no one was safe. A stark photograph of two cold-eyed teen hoodlums handcuffed to each other graced the cover of the paperback edition of *1,000,000 Delinquents* by *New York Times* education editor Benjamin Fine. The book opened with Fine's observation that President Eisenhower's request to Congress for a 1955 budget increase of $3,000,000 to combat juvenile delinquency (over 1954's paltry allocation of $75,000) "is dramatic evidence that finally the people of this country have awakened to the need for a concerted campaign to help our troubled boys and girls. Because in the year 1955 we will have more than one million juvenile delinquents."

Predictably, Hollywood weighed in on the growing crisis of juvenile delinquency since its first rumblings, issuing an array of low- and mid-budget pictures. Among them were *So Young, So Bad*, about an enlightened correctional home for wayward girls, made in 1950; the 1951 *On the Loose*, in which "School-girl by day, thrill-seeker by night" Joan Evans rebels against her middle-class parents;

EDWARD DE ROO, VIN
PACKER, WENZELL
BROWN, AND HAL ELLSON
were among the new breed of
authors specializing in tales of
"the young and the violent."

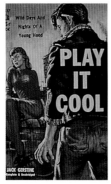

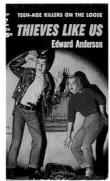

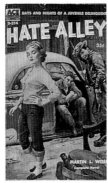

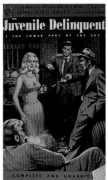

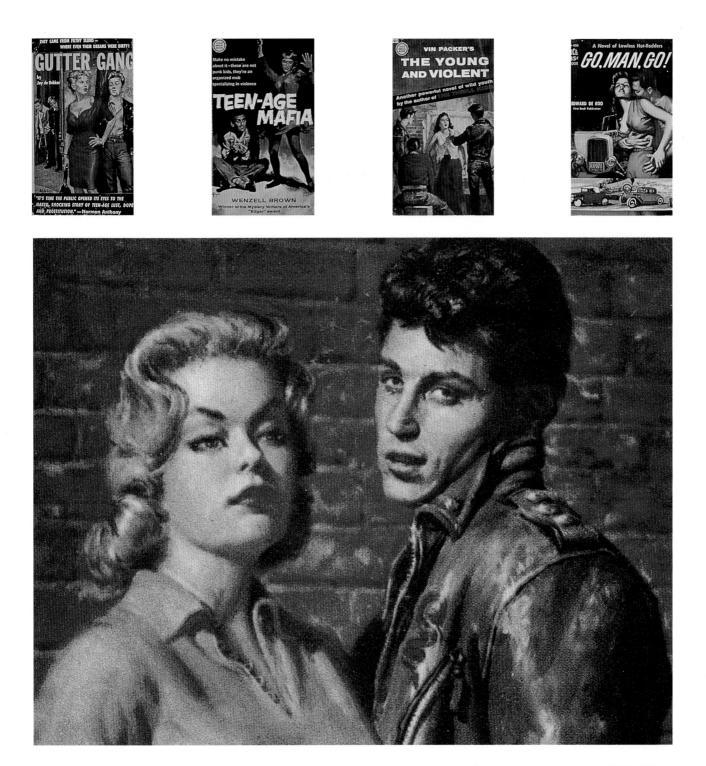

and a trio of 1953 gems: *Problem Girls*, about an *un*enlightened correctional home for girls; *Man Crazy*, with bored teenage girls seduced by unscrupulous adults with cool cars; and *Girls in the Night*, in which slum kids try mightily to overcome their squalid background.

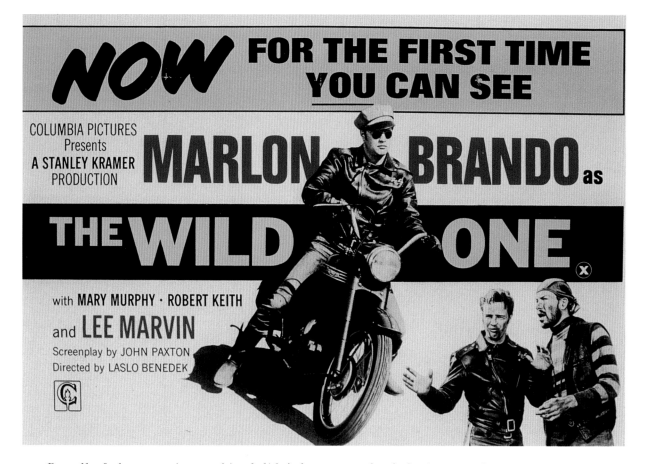

But all of these movies combined didn't have a tenth of the impact of Stanley Kramer's 1954 production *The Wild One*. Originally titled *Hot Blood* in its abortive first release, the film starred Marlon Brando at the peak of his powers. Brando, who would win the Best Actor Academy Award that year for his other movie, *On the Waterfront*, here gives one of his best-remembered performances as the ultra-cool, self-possessed Johnny, the nearly inarticulate leader of a motorcycle gang that casually stops off in a small town and terrorizes its inhabitants. Although a long way from his teenage days, Brando's canny Method performance surely captivated teens in the audience, many of whom probably sat through multiple viewings to memorize such tangy exchanges as "What are you rebelling against?" "What have you got?"

Based on an actual incident that took place in a California town in 1947, *The Wild One* permanently established the studded, black-leather motorcycle jacket as the essence of cool (not to mention the motorcycle itself). It also illustrated how to mumble eloquently, the better to drive parents crazy. But parents would have begged to be driven crazy, plain and simple, had they any notion of what teen culture had waiting for them over the next few years.

Albert K. Cohen's sociological study *Delinquent Boys* (1955; Free Press) offers a precise definition of those one million JDs terrorizing 1950s America:

When we speak of a delinquent subculture, we speak of a way of life that has somehow become traditional among certain groups in American society. These groups are the boys' gangs that flourish most conspicuously in the "delinquency neighborhoods" of our larger American cities. The members of these gangs grow up, some to become law-abiding citizens and others to graduate to more professional and adult forms of criminality, but the delinquent tradition is kept alive by the age-groups that succeed them ...

There seems to be no question ... but that there is a delinquent subculture, and that it is a normal, integral and deeply rooted feature of the social life of the modern American city ... Social control of juvenile delinquency is a major practical problem of every sizable American community. No such efforts at control have thus far proved spectacularly successful ...

The hallmark of the delinquent subculture is the explicit and wholesale repudiation of middle-class standards and the adoption of their very antithesis...The delinquent is the rogue male. His conduct may be viewed not only negatively, as a device for attacking and derogating the respectable culture; positively it may be viewed as the exploitation of modes of behavior which are traditionally symbolic of untrammelled masculinity, which are renounced by middle-class culture because incompatible with its ends, but which are not without a certain aura of glamour and romance.

We see gangs of boys *doing things together*: sitting on curbs, standing on the corner, going to the movies, playing ball, smashing windows and 'goin' robbin'.' These things ... are joint activities, deriving their meaning and flavor from the fact of togetherness and governed by a set of common understandings, common sentiments, and common loyalties.

FAST CARS HAVE FASCINATED TEENAGERS SINCE THE DAWN OF, WELL, CARS. THE VERY FACT THAT AUTOMOBILES WEREN'T *SUPPOSED* TO BE DRIVEN FAST WAS REASON enough to make a self-respecting teen want to *make* it go fast. But doing anything by oneself is never as much fun as doing it with a bunch of pals, and that's how the hot-rod craze got its start. Fatal crackups involving teenagers and their souped-up jalopies had been taking place as far back as 1932. As carmakers improved their product so it could go faster, teens naturally took the opportunity to test the limits of the newest automotive technology. When they manage to break the envelope of those limits, they become a statistic.

Just a year after *Hot Rod* magazine began publication in 1948, *Life* magazine ran an extensive photo-essay, "The 'Hot-Rod' Problem," in its November 7, 1949 issue. Presented as a virtual epidemic, the hot-rodding craze is illustrated with pictures "of teen-age death and disaster," as the article puts it. "In Los Angeles and Dallas, where 'hot-rodding' is at its peak, hundreds of youngsters spend their spare time in suicidal games on wheels....In other localities they play 'pedestrian polo'—just brush 'em, don't hit 'em."

The piece continues with photographs of the "Chicken" game (getting the car up to sixty or seventy mph, then taking your hands off the wheel to see who among your passengers will crack and grab it first), "Rotation" (passengers and driver exchanging positions without letting the vehicle drop below sixty mph), and assorted cases of death and destruction. (It was the popularity of the hot-rod club that led to the rise in car insurance rates for drivers below twenty-five—and

the rates have never gone down since.) Hollywood would have quite a time portraying this "suicidal" teen hobby, in films ranging from *Hot Rod* (1950) to *Hot Rod Girl* (1956) to *Hot Rod Rumble* (1957) to *Hot Rod Gang* (1958) to *Hot Rods to Hell* (1967)—and that only covers the H's! (*Life* ran a nifty follow-up piece, "The Drag-Racing Rage," as the cover feature of its April 29, 1957, issue.)

Trying to kill yourself in a souped-up car may be fun, but for real kicks it's hard to beat terrorizing your high-school teachers, day in and day out. That was the premise of Evan Hunter's 1954 novel *The Blackboard Jungle*, a cultural milestone. Set in a New York City vocational high school, the story revolves around the difficulties faced by new teacher Richard Dadier, a Korean-war vet who finds his class made up largely of miscreants, malcontents, and recidivist criminals. Push soon enough comes to shove, and Dadier ("Daddy-O," the JDs mockingly call him) has to face them down both within and without the walls of the classroom. (Hunter was himself a WWII vet who had taught at a New York vocational school, hence the novel's verisimilitude.)

If MGM had not rushed to make a film of it, *The Blackboard Jungle* might have remained as nothing more than a particularly strong example of JD fiction. It was given a 1955 release, with Glenn Ford starring as Mr. Dadier and then-unknowns Vic Morrow and thirty-one-year-old Sidney Poitier as the student/ gang leaders. In a case of pure serendipity, the song that is played under the film's opening credits, Bill Haley & His Comets' "(We're Gonna) Rock Around the Clock" electrified young moviegoers. It was a catchy but unremarkable tune that had been a minor chart success in 1954, but pegged to the montage of wilding teenagers that opens the film, the song took on another dimension. On July 9, shortly after it had been rereleased, "Rock" became the number-one record in America, and there it remained for nearly two months—the first rock 'n' roll record to top the *Billboard* chart, with total sales climbing into the two million range. By the time *Blackboard Jungle* had finished its run, Hollywood knew what rock 'n' roll was, and so did American teens from coast to coast. From that moment on, the music would never be absent from their lives.

After counting the box-office grosses for *The Blackboard Jungle*, Hollywood knew its first order of business was duplicating its success. Was it a one-shot wonder, or a harbinger of a new order? And exactly how much *had* that Bill Haley ditty influenced those grosses? The first major release to follow *Jungle* was Warner Bros.'s *Rebel Without a Cause*; unlike most of the teenpics to follow, it was an A-budget, big-studio, top-talent production, shot in CinemaScope, no less. "Teenage Terror Torn from Today's Headlines!" the hyperventilating ad copy read; "He's got a chip on *both* his shoulders!" Even so, the film (released October 29, 1955) managed both to define and transcend the teens-in-trouble genre, proving it was here to stay.

Rebel starred the legendary James Dean, who had created a sensation when his first movie, *East of Eden*, was released seven months earlier. But Dean was

AN ARRAY OF MID-FIFTIES
movies, magazine pieces, and
paperback books celebrating
"today's teen-age terror."

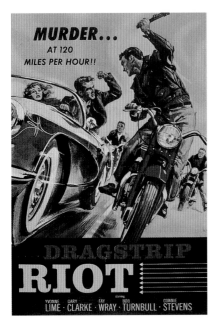

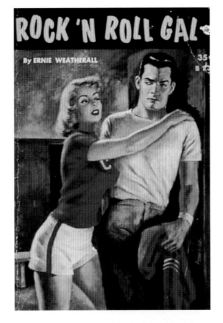

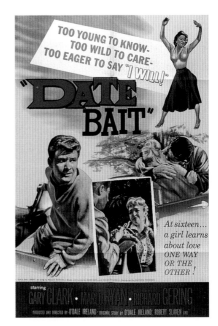

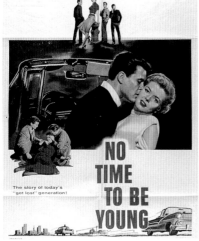

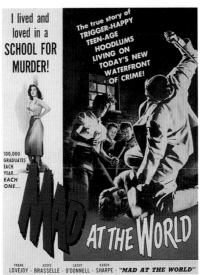

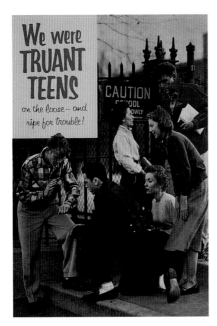

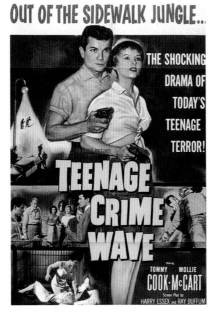

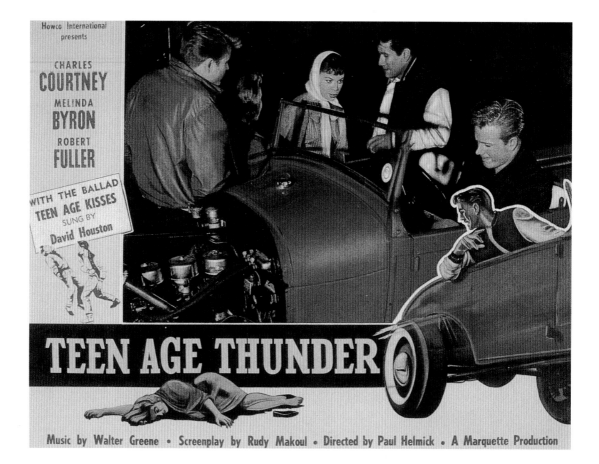

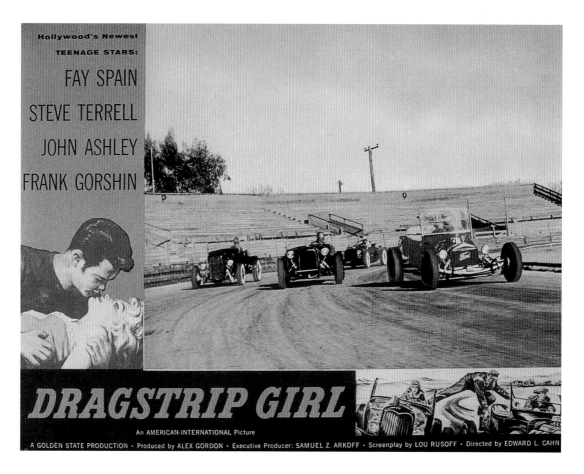

56 HOT RODS, ROCK 'N' ROLL, AND THE KING

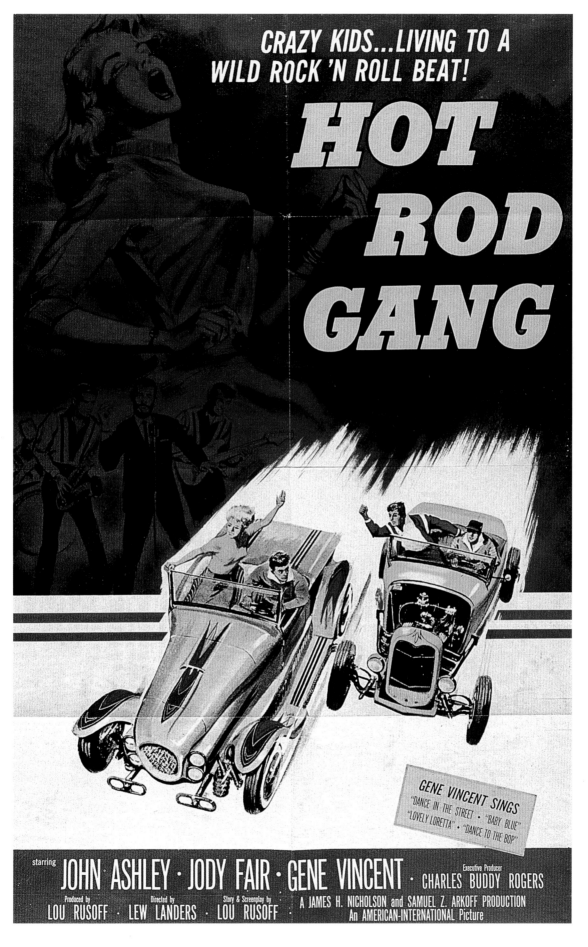

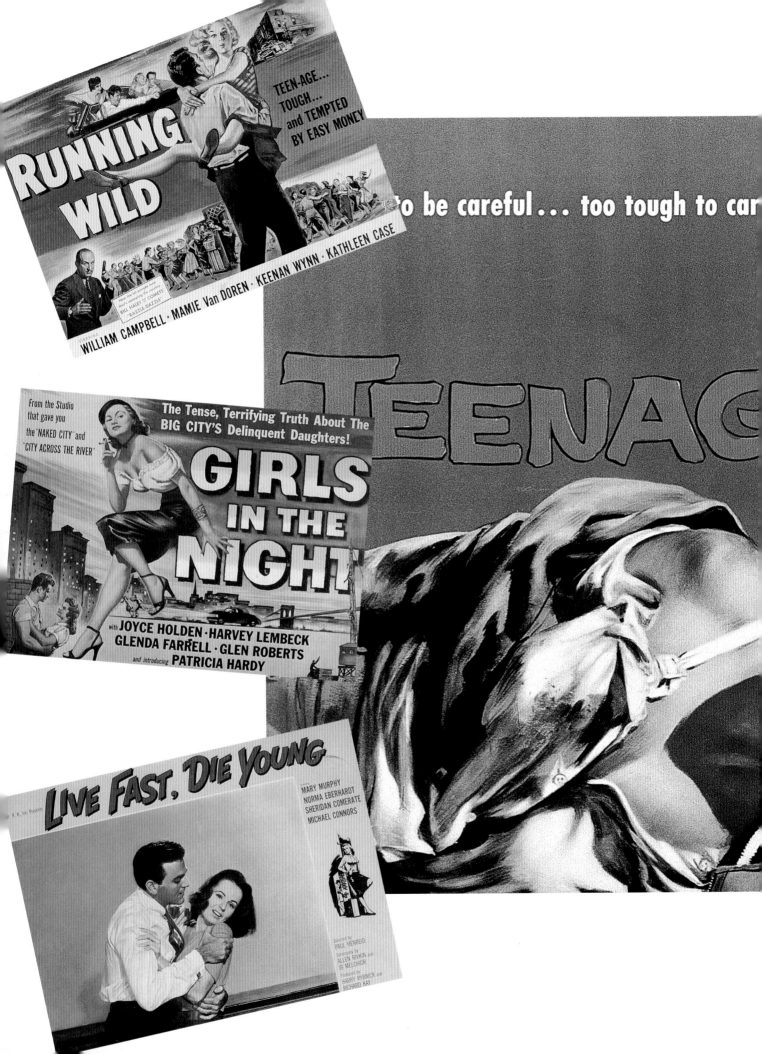

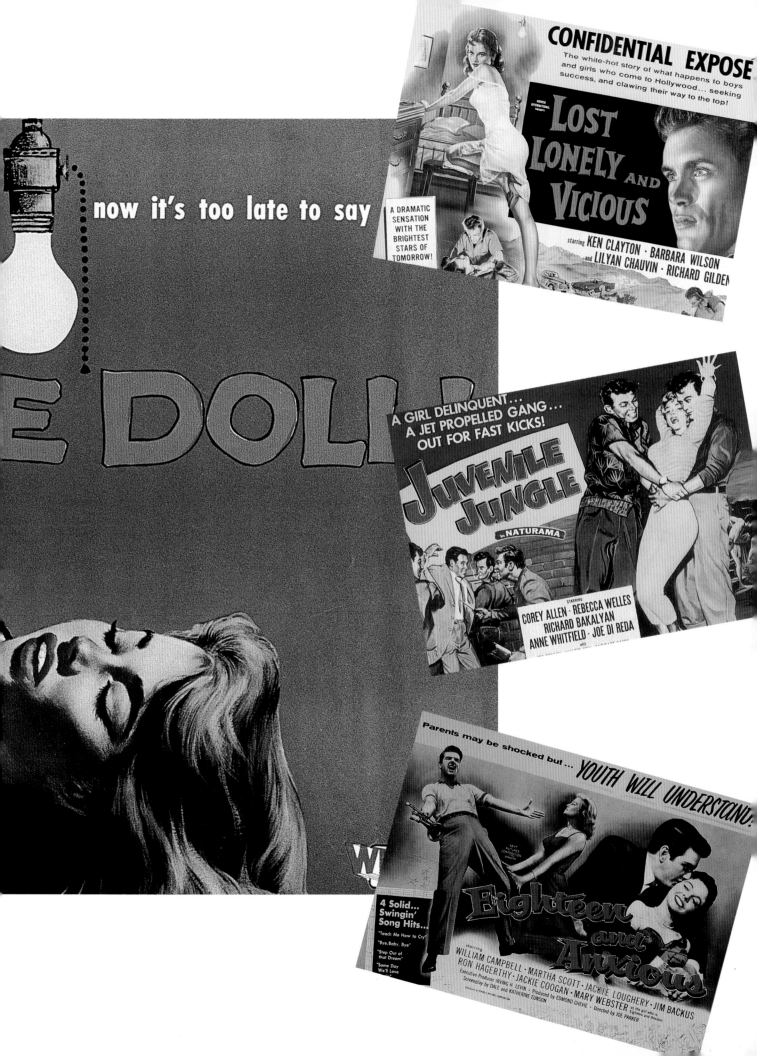

WARNER BROS'. CHALLENGING DRAMA OF TODA

This is
Jim Stark,
teenager--
from a
'good' family--

The reception
committee for the
new kid on the block!

The overnight sensation of 'East of Eden'

JAMES DEAN "REBEL WITHOUT

CINEMASCOPE AND WARNERCOLOR NATALIE WOOD SAL MINEO

already deceased when *Rebel* hit the theaters, victim of a high-speed car crash on that infamous date of September 30, 1955. Five years past being a teenager, Dean nonetheless captured the confused anguish his character, Jim Stark, was experiencing. Ostracized from the new high school he has just begun attending, Jim quickly learns he has to fight the school's Alpha teens for his self-respect; his only solace comes from an oddball kid named Plato (Sal Mineo) and the gorgeous, popular, but equally alienated Judy (Natalie Wood).

Mineo and Wood were in fact still in their teens, a casting decision that saved *Rebel* from some of the awkwardness one feels with the "teen" cast of *Blackboard Jungle*. But it was director and screenwriter Nicholas Ray who deserved the lion's share of the credit for the picture's realism. Ray researched hundreds of Los Angeles police department files on juvenile delinquency so as to incorporate them into his screenplay. Most importantly, all the rituals of teen culture were there on the screen, big as life (or bigger, thanks to CinemaScope)—the chicken races, the switchblade fights, the pack taunting and baiting the loner, the maddening inability of the parents to say or do *anything* right, the ostracized kids bonding with each other.

Actually, the film *is* missing one key element: a rock 'n' roll soundtrack. Had *Rebel* been made just one year later, rest assured, rock songs would have been part of the package. Music aside, there is one key difference between *Rebel* and *Blackboard Jungle*: *Rebel* is told from the teens' point of view. The main characters are all teenagers, with adults entirely in a satellite capacity. *Jungle*, on the other hand, has an adult as its hero, one who cheerfully throttles the young punks who threaten his fellow schoolteachers.

That is the difference between a teenpic and a regular movie, a difference Hollywood learned about when its "serious" pictures about troubled teenagers, like the 1956 *Teenage Rebel*, failed to attract much of a teen audience. Teens wanted to identify with teenage characters, not a crew-cut, contemptuous Glenn Ford just waiting to kick some teenage butt. So they voted with their wallets for movies like *Mad at the World*, *Teenage Crime Wave*, and *Running Wild*, all released in late 1955. *Running Wild*, a showcase for blonde bombshell Mamie Van Doren, was the only one of the group whose producers had the sense to license a rock tune, Bill Haley's "Razzle-Dazzle."

In 1955, when *Blackboard Jungle* and *Rebel* were released, rock 'n' roll was still an emerging force—Elvis Presley hadn't even had a top-ten hit yet. The number-one songs that followed "Rock Around the Clock" on *Billboard*'s chart were the finger-poppin' "The Yellow Rose of Texas" by Mitch Miller, "Love Is a Many Splendored Thing" by the Four Aces, and "Autumn Leaves" by Roger Williams. On the other hand, in April of 1955 six of the top-ten juke box hits (tallied by number of plays) were either rock or rhythm and blues tunes. *Life* magazine carried a cheery feature in its April 18 issue titled "Rock'n Roll" [*sic*], illustrated with photos of ecstatic Los Angeles kids dancing to a Fats Domino

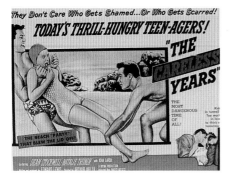

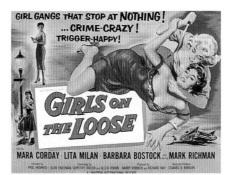

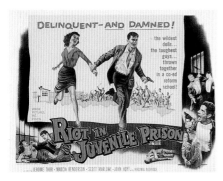

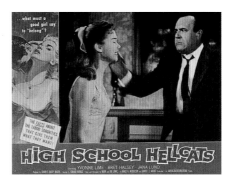

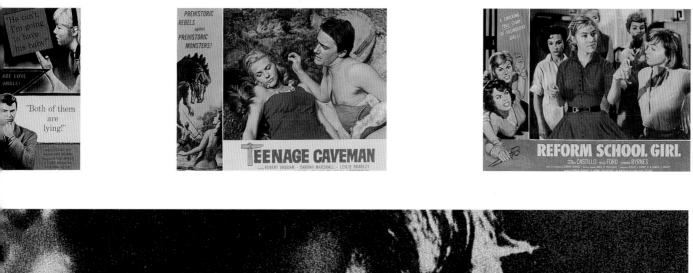

concert and New York City teens attending an Alan Freed broadcast at the WINS studio. But that issue also ran a companion piece called "A Question of Questionable Meanings," focusing on *Variety* magazine's recent diatribe about rock's suggestive "leer-ics" (although ultimately *Life* seemed to pooh-pooh *Variety*'s charges).

Freed, who was born in Johnstown, Pennsylvania in 1922 but grew up in Cleveland, was the visionary who had dubbed the music "Rock 'n' Roll" (quoting the 1947 song by Wild Bill Moore, "We're Gonna Rock, We're Gonna Roll") back when he was still DJ'ing his "Moondog Rock & Roll Show" from Cleveland's WJW, where he had worked since 1951. By moving in September of 1954 to WINS in New York, where his show was christened "Alan Freed's Rock & Roll Party," he was able to expand his base and reach out to ever larger audiences, in part through the live all-star R&B/R&R shows he had been promoting since 1952. Freed championed black R&B artists like Hank Ballard & the Midnighters, Ruth Brown, Joe Turner, Johnny Ace, Fats Domino, The Drifters, and The Clovers, helping them cross over to a white listenership—thereby enlarging the earning powers of those artists by quantum sums.

It was in 1955 that Little Richard, Chuck Berry, The Platters, The Moonglows, Bo Diddley, The Cadillacs, The Five Keys, and LaVerne Baker all broke through the color barrier on the radiowaves—and to a one they owed their success to Freed. These artists and their peers were responsible for making the *righteous* teen music of the day. KleenTeen idol Pat Boone and his white-bread remakes of R&B classics like Fats's "Ain't That a Shame"—the only top-five song on *Billboard* that was even *pretending* to be rock 'n' roll as 1955 ended—were last gasps of the time-honored tradition of homogenizing "race" (i.e. black) music for mainstream (i.e., white) radio play, which obviously helped determine sales. But the change was gonna come, whether Pat Boone liked it or not. As Fats Domino explained in a bylined article in the August 1956 issue of *Rhythm & Blues*,

> Now if you'll allow me I'll clue you in on the "R&R" vs. "R&B" bit…At one time pop fans stayed on their side of the fence and R&B buyers remained in their own territory. Then things started to "pop" for the Rock 'n' Roll fans, and the two fields started to merge. Everyone got on

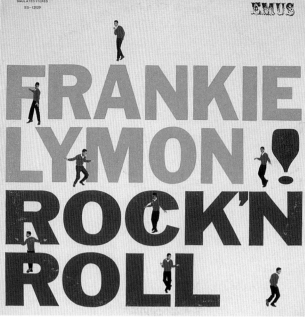

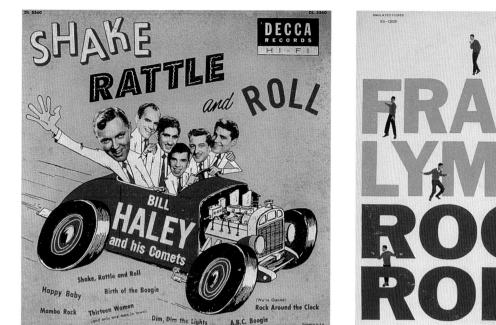

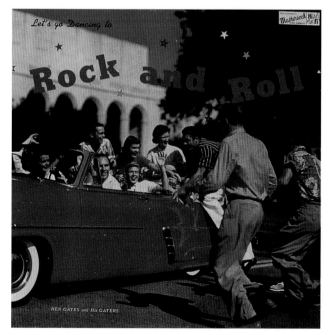

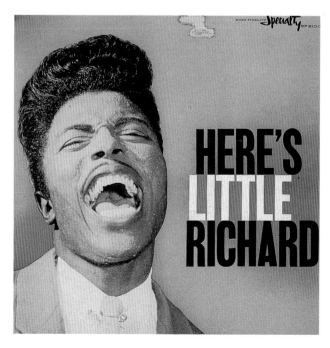

elvis presley

IN HOLLYWOOD

15¢

over 70 photos!

FIRST SCENES FROM ELVIS'
PREMIERE MOTION PICTURE

IND

A VERITABLE EXPLOSION
of magazines devoted to the
phenomenon of Elvis Presley saw
publication in 1956 and 1957.

that wailin' kick. Now if anyone asks you about R&B, say you got the info straight from me that there's no difference in Rhythm and Blues and Rock 'n' Roll.

Thanks to the enterprise of Freed, the promotional power of RCA records, and Hollywood's proven ability to jump on a bandwagon just as it was pulling out of the station, all that changed in 1956. The key event of the year, of course, was the breakthrough of Elvis Presley, whose contract with tiny Sun Records had been sold to the RCA juggernaut in 1955. His first RCA record, released on January 27, 1956, was "Heartbreak Hotel"; after considerable exposure on shows like *Steve Allen* and Tommy and Jimmy Dorsey's *Stage Show* over several months, it became his first number-one hit on April 21, 1956. It stayed at the top of the charts for eight weeks, but Elvis was just getting started. His follow-up tune, "I

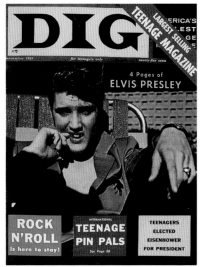

Want You, I Need You, I Love You," hit the top of the charts in July, while in August, his two-sided monster, "Hound Dog"/"Don't Be Cruel," began an eleven-week run as the top single in America, ultimately giving him dominance for twenty-five weeks of the year.

While Elvis may have ruled the world of Teens in 1956—who else had eleven magazines devoted entirely to him, not to mention dozens of cover shots on everything from *TV Guide* to *Photoplay?*—the court he had surrounding him should not be overlooked. Those black artists who'd crossed over had been joined by newcomers to the pop charts like Carl Perkins (whose "Blue Suede Shoes" was such a great anthem that Elvis had to swallow his pride and cover it!), Frankie Lymon and the Teenagers (whose "I'm Not a Juvenile Delinquent" carried the unlikely refrain, "It's easy to be good/It's hard to be bad"), Little Willie John, Gene Vincent & His Bluecaps, The Five Satins—it was multi-cultural teen heaven. And it only got better in 1957. Jerry Lee Lewis...Buddy Holly and the Crickets...Ricky Nelson...Sam Cooke...The Everly Brothers. All of these were giants striding across your universe, if you were fifteen and breathing. (Of course, there were also number-one songs that year by Tab Hunter, Paul Anka, Pat Boone and Perry Como—but who ever said it's a perfect world?) And the King spent another twenty-five weeks at number-one with "Too Much," "All Shook Up," "(Let Me Be Your) Teddy Bear," and "Jailhouse Rock"/"Treat Me Nice." It was more than enough to convince Hollywood that it had to invest not only in teen-pics, but in teen-pics slathered with plenty of rock 'n' roll.

Logical enough, but easier said than done. What rock stars could be trusted to carry an entire movie? Maybe one—Elvis—but his manager, Colonel Parker,

wasn't letting his golden goose be used just any old way. So it was impresario and spiritual leader Alan Freed who got the call from Hollywood. He was used as the glue to hold together a thin story involving misunderstood teens, superstars Bill Haley & His Comets and The Platters, and insensitive parents in *Rock Around the Clock*, a 1956 Columbia cheapie that took the then-enormous leap of letting the rock stars perform right on the screen, instead of just playing their music under the credits. The picture was a smash at the box office, and Freed was hired immediately to make *Rock, Rock, Rock!*, another musical that had nominal stars Teddy Randazzo (wooden as a tree stump) and Tuesday Weld (cute as a trunkful of buttons) fussing about prom dresses and allowances while a phenomenonal aggregation of the day's top rock and R&B stars performed: Chuck Berry (his duckwalk captured for posterity), Frankie Lymon and the Teenagers, The Moonglows, LaVern Baker, The Flamingos, and Johnny Burnette. Unfortunately for Freed, he too tried to sing, but his "talkin'" "Rock 'n' Roll Boogie" number was enough to send one begging for Perry Como. (After the glory of starring in his own biopic, *Mr. Rock and Roll*, in 1957, Freed made his final screen appearance in 1959 in *Go, Johnny, Go!*; soon after, he was brought up on payola charges, on which he was indicted in 1960.)

The non-rock teen movies kept coming in 1956 as well—serious JD dramas like *Crime on the Streets*, written by Emmy-winner Reginald Rose; *Rebel* knock-offs like AIP's *Hot-Rod Girl* ("Chicken-Race! Rock 'n' Roll! Youth on the Loose!"—that oughta cover it!); and shameless exploitation films like the wonderfully junky *The Violent Years*, written by cult director Ed Wood. The following year was even better: Dino, a sensitive showcase for Sal Mineo; *The Delinquents*, Robert Altman's neo-realist yarn, shot in Kansas City; *I Was a Teenage Werewolf* and *I Was a Teenage Frankenstein*, for fans of utter alienation; *Hot-Rod Rumble* and *Dragstrip Girl*; Mamie Van Doren's jumpin' *Untamed Youth*; and the catfight special *Reform School Girl*.

But the best teen screen efforts of 1957 just may have been the pair starring the King, *Loving You* and *Jailhouse Rock*. Elvis had finally made his maiden film run late in 1956 with the Civil War soap opera *Love Me Tender*; but that effort really proved nothing, except that the title tune was a lousy song whether it was strummed in 1956 or 1861. Back in a contemporary mode, though, with his hair dyed jet-black, Elvis had a field day playing out his own thrilling rise to fame in *Loving*

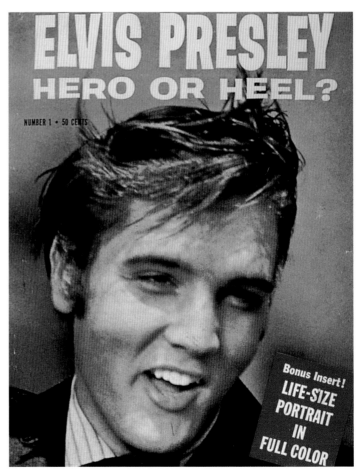

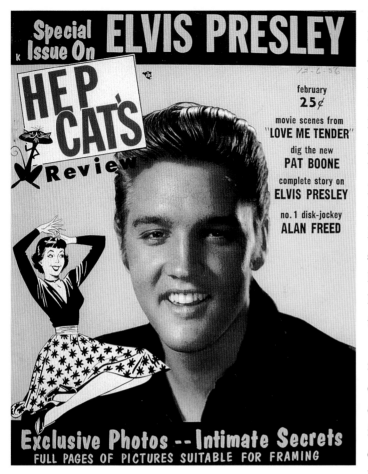

You (catch that steamy version of "Mean Woman Blues"!), and dancing with a bunch of convicts in *Jailhouse Rock*. It was entirely appropriate that the premier issues of both *Hep Cats Review* (February 1957) and *Cool* magazine (April 1957) were special Elvis issues (although the latter snuck in nice pieces on Freed, Bill Haley, Fats Domino, Gene Vincent, and—yikes!—Pat Boone and Sammy Davis, Jr.). There was also the unintentionally hilarious high-concept magazine, *Tommy Sands vs. Belafonte and Elvis*, in which the King's throne is supposedly threatened by the wimpy Sands (who had one top-ten hit, "Teen-Age Crush") and the king of Calypso, Harry Belafonte (whose lone top-ten tune was "Banana Boat [Day-O]").

It was beginning to look like the party would never end, when suddenly it did. Elvis got his draft notice from Uncle Sam, and even the wiles of Colonel Parker could do no more than delay the inevitable for a few months (primarily for Elvis to cut a few tunes and film the movie *King Creole*) before sacrificing his sideburns for the obligatory crewcut on March 24, 1958. Teens gasped, wept, and gnashed their teeth, then got hold of themselves and forged on, strengthened by the knowledge that hair can always grow back. Perhaps they also sensed that kick-ass tunes like "Hard-Headed Woman" and "A Big Hunk o' Love" were in the can, just waiting for time-sensitive release.

But the truth is that irreparable damage was done to the teen world in the King's absence. It's hard to say why—The Everly Brothers and Chuck Berry kept making great music; Mamie Van Doren and AIP kept making fun films; *Cool*, "The Magazine for Hipsters," kept publishing; T-Birds and Olds 88s still looked great at the drive-ins—but something was wrong. It couldn't all be due to some missing sideburns. Elvis would be back—wouldn't he?

Who would have dreamt that the answer was No.

Jimmy's own scrapbook! see pag

OFFICIAL JAMES DEAN

Anniversary Book

DELL 25c

HOW HE LIVED

HOW HE LOVED

HOW HIS GENIU FLOWERED

WHY HE DIED

WHY HE LIVES OI

JIMMY DEAN IN "GIANT"

The only teen idol in this grouping not to have enjoyed his idolization while alive, James Dean—who made only three films before his death on September 30, 1955, at age twenty-four in a high-speed car crash—was a moody, sensitive, ultimately mysterious soul revered for his portrayal of teenaged characters in two of his three pictures. Dean clearly based his method-acting technique on that of Marlon Brando, who had briefly become a teen idol himself after the release of *The Wild One* in 1954. Like few others before or since, Dean was able to convey the almost self-choking anguish of adolescence, first as the tortured Cal in *East of Eden*, the only one of his films released while he was alive, then as the tortured Jim in *Rebel Without a Cause*, and finally as the egotistical-but-tortured Jett in *Giant*.

Had *Rebel* not come out less than a month after Dean's unnecessary demise—he had been given a ticket for speeding just hours before he cracked up at 110 mph—it's possible that the adulation teens exhibited for the departed actor would have been less fervid. But it must have been almost overwhelming for a six-

teen-year-old back in 1955 to have watched *Rebel*—CinemaScope and all—on the big screen and experienced Dean's anguish-drenched performance, knowing that he had been alive just weeks earlier. "Jim Stark—from a 'good' family—what makes him tick...like a bomb?" Warner Brothers promo material asked. Well, the bomb went off.

For the next two years, entire magazines were published celebrating Dean's brief life: *The Real James Dean Story*, *The Official James Dean Anniversary Book* ("How He Lived...How He Died...How His Genius Flowered...Why He Died...Why He Lives On"), and, creepiest of all, *Jimmy Dean Returns!—Read His Own Words From Beyond* ("How I Found a New Life Beyond Death Through One Girl's Love..."). A passel of paperback biographies also appeared over the next few years, and to this day new volumes about the cryptic, doomed star continue to be published. All this, and a nationally released 1957 documentary film, *The James Dean Story*, compiled by Robert Altman, with a theme song ("Let Me Be Loved") sung by ersatz teen idol Tommy Sands.... Now *that* is what is meant by a cult following.

On May 3, 1958, I was seventeen years old and a senior at Haverhill High School. I had already attended two live R&B shows in Boston, and I certainly wasn't going to miss the chance to see an Alan Freed show that had finally traveled north! The headliners included just about everyone that mattered at the time—Jerry Lee Lewis, Buddy Holly and The Crickets, Chuck Berry, Frankie Lymon (already separated from The Teenagers), The Diamonds, The Chantels—and several acts of lesser stature, like Danny & The Juniors, Dickey Doo & The Don'ts, Larry Williams, and the legendary Screamin' Jay Hawkins.

Along with some friends, I headed into Boston that night of May 3. The show was to be held at the old Boston Arena, which at that time was certainly not located in the best part of Boston. But it was not in the worst section, either. Two of my friends and I were seated about twenty yards to the left of the stage, in the first-level box seats. The crowd was not "predominately" white; it was a racial mix that was about forty percent black. On the arena floor, chairs had been set up facing the stage; but the box seats where I was sitting, which were mostly filled with Black fans, had separate, moveable red seats.

The show turned out to be all that we had expected, given the talent that had been assembled. Larry Williams wowed the crowd by lying prone on top of a grand piano and reaching over backwards to play the keys! Of course there was a heavy police presence at the show, but this was not unusual in the paranoid Boston of 1958. The audience had been instructed to stay seated and not dance in the aisles, common practice for a rock show. (Talk about wishful thinking!)

As the second half of the show began, a noticeable feeling of tension began to mount. It was during Chuck Berry's closing performance that the crowd problems truly began. When the disturbance erupted—and there's no other word for it than *erupted*—I remember poor Chuck and his band running to the rear of the stage and up the band platform, where he hid behind the drummer for cover. One of my friends thought this was all part of the act, but he couldn't see the look of fear on Berry's face.

The kids sitting next to me had been drinking steadily throughout the show's second half. At one point, the dude on my right stood up on his chair and promptly slid down to the floor, where he remained in a stupor for the next ten minutes. By the time Chuck

Berry was on, the kid had revived to the point where he and his buddies began tying red-speckled white bandanas around their heads, identifying themselves as members of the notorious Boston street gang, Band of Angels. Across the way, another gang began donning *their* colored bandanas. It soon became obvious that several rival gangs had chosen that night, and this place, to resolve their differences. The trouble wasn't racial so much as territorial.

Once the fights broke out, the lights came up and the police began to move in the direction of those eruptions. After awhile, Alan Freed came onstage to issue his "big" statement in the hope of restoring order. He certainly wasn't trying to incite any additional trouble, as some newspapers reported, and never mentioned the police directly. All poor Alan said was, "They won't put the lights back out, kids. I guess they don't want you to have any fun."

I remember that this was when the guy next to me picked up his red chair and threw it over the railing onto the floor, which was eight or ten feet below us. As various objects began raining down from above, I suggested to my friends that we get the hell out of there. There was an exit ramp just to our right, and we ran down it, to a long corridor below. Hoards of people were running with us, screaming and yelling, so the three of us peeled off down a side corridor, found a fire door, and kicked it open. That brought us into a short alley, which we ran down. A jump over a short wooden fence put us on the street in front of the Arena.

We headed diagonally across the street toward the parking garage where we'd left our car. Being the "heroes" we were, we jumped in the car, locked the doors, and waited for our two pals who had been sitting in a different part of the Arena. For ten minutes, all we could hear were the screams and shouting outside the garage. When our friends finally showed up, we drove back to Haverhill as fast as we could, arriving around one A.M.

Later we read that Alan Freed had been sighted signing autographs after the show—extremely doubtful from our point of view, given what was going on in the street at the time. In fact, we found most of the newspaper accounts of the "riot" to be exaggerated, and the notion they perpetuated that it was Alan Freed and the rock 'n' roll performers who were at fault for the gang violence is simply ridiculous. Let's face it, Freed made good news copy! But it is a wonder that more people weren't seriously injured that night.

[Note: George Moonoogian went on to graduate from Haverhill High School in 1958 and has been on the faculty there since 1969.]

TEENAGERS STILL COULD FIND PLENTY TO ENJOY AS THE FIFTIES DREW TO A CLOSE, EVEN WITH ELVIS STATIONED HALF A WORLD AWAY IN GERMANY. There was the cool dialogue of Mamie Van Doren's latest screen triumph, *Girl's Town*: "Go bingle your bongle"; "You want to go to jailsville, huh?" There were cool tunes like Dion and the Belmonts' "A Teenager in Love," Ricky Nelson's "It's Late," and the Drifters' "There Goes My Baby." There were cool TV shows like *77 Sunset Strip*, which spawned the novelty song "Kookie, Kookie (Lend Me Your Comb)" by two of the show's stars, Edd Byrnes and Connie Stevens.

But there was so much around that year that was decidely uncool, like the movie *Blue Denim*, a "message" picture about teen pregnancy (always a major downer for the drive-in crowd). There was also the demise of Buddy Holly, The Big Bopper, and Ritchie Valens in a plane crash in February of 1959—a shocker, the biggest to hit the teen world since the death of James Dean. And Frankie Avalon, whose 1958 "Dede Dinah" was possibly the worst top-ten Rock tune of all time, now had the syrupy "Venus" at number one, taking the top spot away from The Coasters' knowing, comical JD anthem "Charlie Brown." What was happening with rock 'n' roll, anyway?

Of course, the nineteen-year-old Avalon had something going for him that The Coasters didn't—the backing of the powerful Dick Clark, host of the national TV show *American Bandstand* and heir to the throne of Alan Freed, who was being investigated for taking payola in return for airplay of certain records. (Clark would also be investigated for the same charges, but nothing was ever proven.) By 1959, *American Bandstand* had become the most influential teen show on

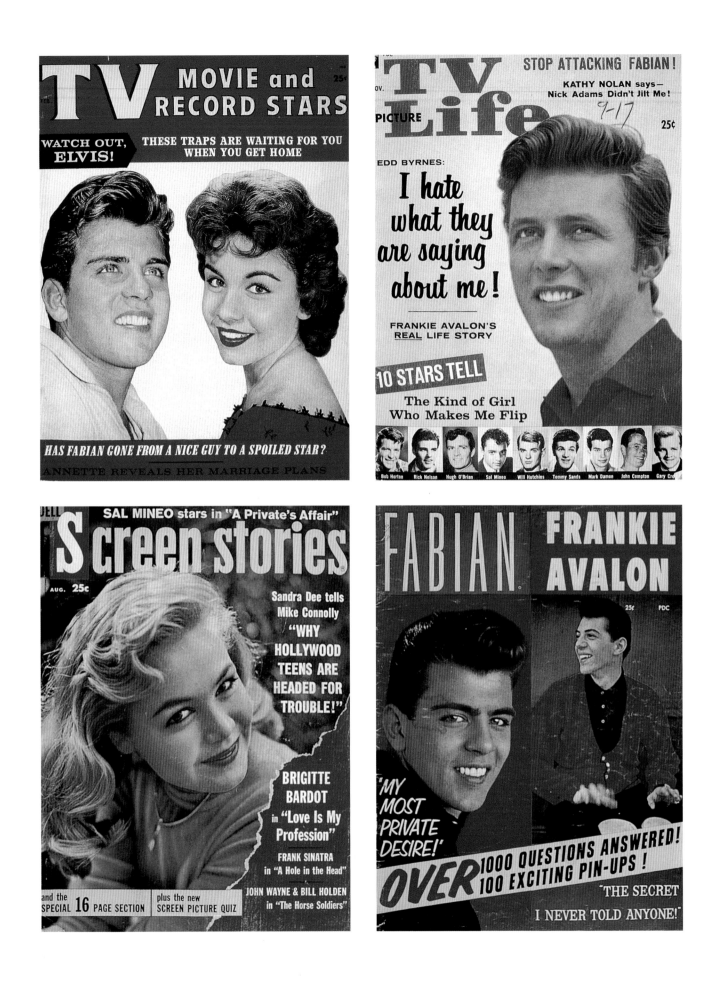

television. It had started as the local program *Philadelphia Bandstand*, but caught on once Clark replaced original host Bob Horn (a chronic drunk), and went national on ABC on August 5, 1957.

Clark was a genius in many respects, not the least being his willingness to devote plenty of airtime to the local Philly cats and kittens who danced on the show—Carmen Jimenez, Carol Scaldeferri, Myrna Horowitz, Denny Dziena, and the calf-eyed couple Justine Carrelli and Bob Clayton chief among them. This helped them connect with the kids watching at home, who knew they could be *at least* as good-looking and hip as *this* gang if they could just get the dance steps down and work on the clothes a little bit.

Clark's main mission, however, was building up his own crew of home-grown, South Philly teen idols, in whose record sales he shared a financial interest. In 1959, that crew included Frankie Avalon (two number-one hits that year); Bobby Rydell (who would get to sing in Dick Clark's 1960 movie, *Because They're Young*, in which Dick played a goodie-goodie teacher); and Fabian (three lame top-ten hits in 1959, plus the movie *Hound Dog Man*). Over the next few years the redoubtable Chubby Checker would be in the spotlight, popularizing one national dance-craze tune after another, from the Twist to the Pony to the Fly to the Limbo. More than anyone, it was Clark who rendered teen culture like so much chicken fat, skimming off the high-cholesterol fun to leave behind a thin broth—"good" for you, supposedly, but entirely devoid of flavor.

Nineteen fifty-nine was also the year of Sandra Dee, who was starring in *Gidget*, a not-entirely-uncool teen romance about a fifteen-year-old Malibu girl who becomes the mascot of a band of surfers known as the Malibu Go-Heads. She falls in love with two of them, but understandably, neither takes her seriously. Based on a 1957 novel by Frederick Kohner (drawn from his daughter's own adventures) that earned great notices—one paper likened it to *Catcher in the Rye*—*Gidget* was the first look many teens had of the distinctly Californian surfin' subculture that in the not-too-distant future would seduce the imagination of American youth.

On March 5, 1960, Elvis was discharged from the Army. Hope ran high that he would seize the day and rescue American teenagers from the creeping doldrums, but it was not to be. The Elvis who came back from Germany had lost his lean and hungry look—too many fried peanut-butter-and-bacon sandwiches no doubt—and, more seriously, he had left his insinuating sexiness parked at the Berlin Wall. His first 1960 release, "Stuck on You," hit number one, as did his next, "It's Now or Never," and his next, "Are You Lonesome Tonight?" But these creamy ballads and pseudo-operatic tunes were not exactly the stuff of legend—they were closer to the stuff that fills the middle of a Twinkie. Eventually, the King would get his chops back to a degree and cut some decent 45s, but he never fully regained the momentum or energy that had once seemed bottomless.

As the sixties unrolled, there would be plenty of pop music that was wholly

worthy—tunes by Dion, the Everlys, Roy Orbison, the Shirelles, Del Shannon, Gene Pitney (once he canned the ballads)—but there was so much more that was not. All those teen idols seem such a diluted bunch when the names Bobby Vee, Paul Anka, Connie Francis, Bobby Vinton, Neil Sedaka, and the aforementioned Dick Clark artists are factored into the equation.

It took until 1963 for something new and interesting to happen to teen culture, and that was simply the emergence of the beach subculture. For California kids, sand 'n' surf had been around since the forties, but one can understand why the teens of, say, Milwaukee weren't immediately caught up in the excitement. The Beach Boys caught the wave and the imagination of teens everywhere, in 1963, with a dazzling array of hit songs celebrating both beach and car culture—they have *cars* in Milwaukee, right?—including "Surfin' Safari," "Surfin' USA"/"Shut Down," "Little Deuce Coupe"/"Surfer Girl," and (in deference to high-school culture) "Be True to Your School." The Beach Boys' success was complemented by the oeuvre of Jan & Dean, who'd been around since 1958 doing conventional pop tunes, but who now chipped in with fun-in-the-sun anthems like "Surf City" (co-written by Brian Wilson of the Beach Boys), "Drag City," and (early in '64) "Dead Man's Curve," a death-by-drag-racing ditty that had state-of-the-art sound effects recreating a fatal collision. Add such instrumental smash singles as The Surfari's "Wipe Out," the Ventures' remake of "Walk Don't Run," and the Chantay's "Pipeline" (a surfin' term for being inside the curl of a wave), and you, too, could smell the saltwater and feel the sand between your toes.

All that is without the dubious contributions of AIP's *Beach Party*, the 1963 movie starring Frankie Avalon and Annette Funicello (the former cute Mouseketeer, who was by then filling out a bathing suit in impressive fashion) that started a new KleenTeen cycle of increasingly moronic sand 'n' surf pictures: *Bikini Beach* and *Muscle Beach Party* (1964), *Beach Blanket Bingo* and *How to Stuff a Wild Bikini* (1965)—a few points for the title on that last one—along with non-AIP films like the 1964 trio *Ride the Wild Surf* (Fabian and Tab Hunter team up, at last!), *Surf Party* (Bobby Vinton "acts"—oy!), and *The Horror of Party Beach*, and such 1965 sand pebbles as *Beach Ball*, *Wild on the Beach*, and *The Girls on the Beach*.

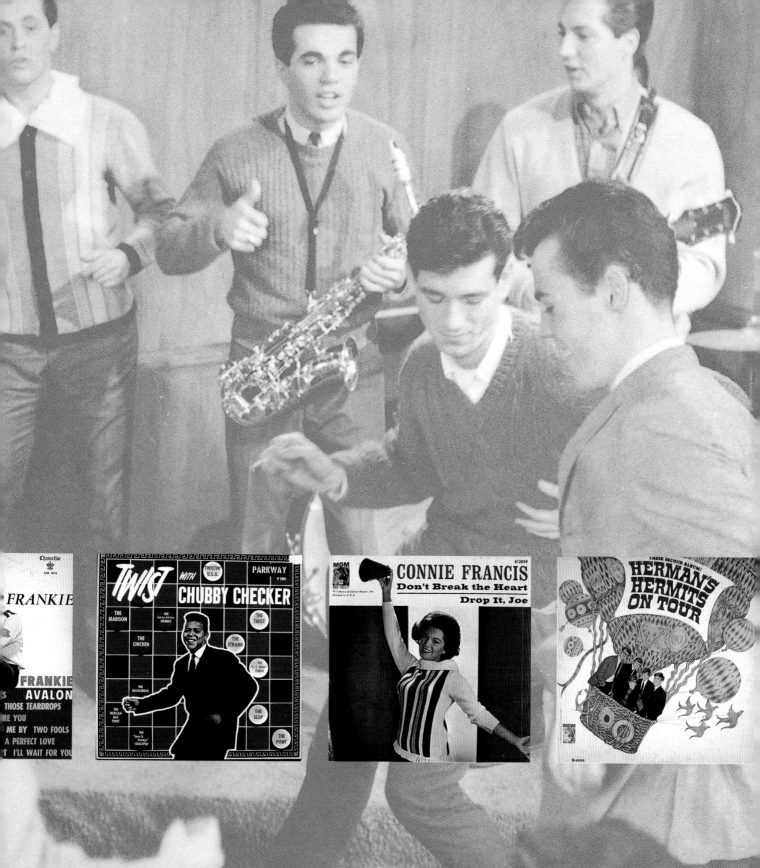

STARRING

ANNETTE FUNICELLO
DWAYNE HICKMAN
BRIAN DONLEVY
BUSTER KEATON
BEVERLY ADAMS
HARVEY LEMBECK
JOHN ASHLEY · JODY McCREA
AND GUEST STAR
MICKEY ROONEY

INNERS
PERTS...

ng course in
E BIRDS
E BEES
BIKINIS

...in six very
asy lessons

Thrills and spills
in the wildest
MOTORCYCLE RACE
ever run!

SEE
CHAMPION
SURFERS!

SEE
THEM RIDE...
the toughest, tallest,
most thundering waves
in the world!

SEE
THEM CHALLENGE...
the wild waters of Hawaii...
the world's top champions
competing with each other!

SEE
THEM STAR...
in the most exciting,
breath-taking surfing action
ever filmed!

RIDE
THE
WILD
SURF
IN COLOR

These flicks constituted the kind of insufferable "fun" that made American teens ripe for conquest by the British invasion of '64—but call it a last gasp of innocence, if you prefer; this was the last time teenagers would have the chance to see Fabian and Tab Hunter fight over Shelley Fabares *and* hear Dick Dale and the Del-Tones serenade a gaggle of beautiful, bronzed, bikinied babes.

Not that surf music and beach movies were the real cause of the doldrums then suffusing American teen culture; far from it. Consider: on February 29, 1963, the top four "rock 'n' roll" (and we use the term loosely here) songs on *Billboard*'s chart were, in order, "Hey Paula" by Paul & Paula; "Walk Right In" by the Rooftop Singers; "The Night Has a Thousand Eyes" by Bobby Vee; and "Loop De Loop" by Johnny Thunder. Exactly one year later, things would be very, very different—thank goodness.

It was high time to bring on the Beatles.

So much has been written over the years about the advent of the Fab Four, their rise to glory and their (temporary) fall from grace that, of necessity, just a few of the highlights of Beatlemania, and the Britmania that followed in its wake, will be touched on here.

We Americans tend to remember Beatlemania as a vast operation orchestrated as cleverly, and as ruthlessly, as D-Day—and it was!—but it is worth noting that it took a while to develop in England over the previous year and a half. "Love Me Do," their first British chart single (written by John Lennon and Paul McCartney during their days at Quarry Bank High School in Liverpool) made it only to number seventeen in December of 1962. Their second release, "Please Please Me," hit number two in England in the spring of 1963, but the Beatles' first number-one hit on the British charts was "From Me to You," which topped the list in May of 1963 (just when the Beach Boys were riding high in the States with "Surfin' USA"). But the U.S. releases of those tunes on the Vee Jay label in mid-1963 landed with a thud. "She Loves You" was even bigger in England, but its American release on the teeny Swan label went nowhere; in the meantime, the Angels were number one in the U.S. with the saucy "My Boyfriend's Back."

It wasn't until the instant success of "I Want to Hold Your Hand" in England that Capitol Records got on board; they'd passed on the lads' earlier singles. A

release date of January 1964 was scheduled, but there was pressure to "break" the song here by DJs who were hip to this potential phenomenon, and Capitol moved up the release to December 26 and upped its pressing from 200,000 to a cool one million copies. The day "Hand" was released in the States, "Dominique" by the Singing Nun was number one on *Billboard*, and it was held at bay through the entire month of January by (of all things) Bobby Vinton's dreadful "There! I've Said It Again," a remake of a syrupy 1940s hit.

Jack Paar was actually the first television host to screen clips of the Beatles in performance, on January 3, 1964, but Paar's dismissive "Yeah, yeah, yeah" was quickly forgotten in the wake of Ed Sullivan's historic shows of February 9 and 16, with the lads performing live before a crowd consisting almost entirely of hyperventilating females, a crowd so frenzied that it forever redefined the accepted limits of the human scream. On February 1, "I Want to Hold Your Hand" hit number one on the *Billboard* chart, a position it held for seven weeks (the record eventually went on to sell some 15 million copies worldwide). It was replaced at the top of the March 21 chart by "She Loves You," which two weeks later handed over the number-one spot to "Can't Buy Me Love"; it was the first time any artist had scored three consecutive number-one hits. On that historic week of April 4, 1964, the Beatles held down the entire top five, also the first time that feat had been registered. And a week later, the Beatles had an incredible fourteen songs on *Billboard*'s "Hot 100" chart.

The first British group to follow in the wake of the Beatles was the Dave Clark Five, although their first U.S. release, "Glad All Over," didn't make the top five, and their follow-up, "Bits and Pieces," stopped at number four. Still, the quintet was formidable enough (or so it seemed back then, for about fifteen minutes) to inspire a mini-wave of magazines along the lines of *The Beatles Meet The Dave Clark Five*—nothing less than total control of the teen world were the implied stakes. (We know who won that one!)

As 1964 rolled out, many other British groups, including The Searchers, Gerry and the Pacemakers, Peter and Gordon, The Animals, The Zombies, The Rolling Stones, Manfred Mann, Herman's Hermits, and The Honeycombs, made an impact on the U.S. charts. The British invasion was an unequivocal success, but not an utter wipe-out: American artists like the Beach Boys, the Four Seasons, the Supremes, Mary Wells, and Roy Orbison all proved to be resilient, scoring number-one hits

AS HAD HAPPENED WITH ELVIS eight years earlier, the Beatles gave both the music and publishing industries a shot in the arm when they conquered pop culture in 1964.

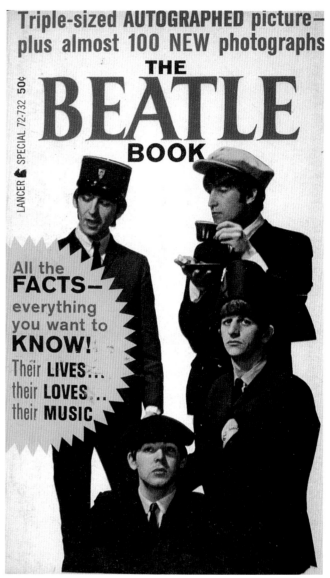

MACFADDEN
MB
BOOKS

50-210

Here it is—The Beatle Book!
—crammed with facts,
figures and fotos on
the most fabulous foursome
in show business!

ALL ABOUT THE BEATLES

by Edward De Blasio

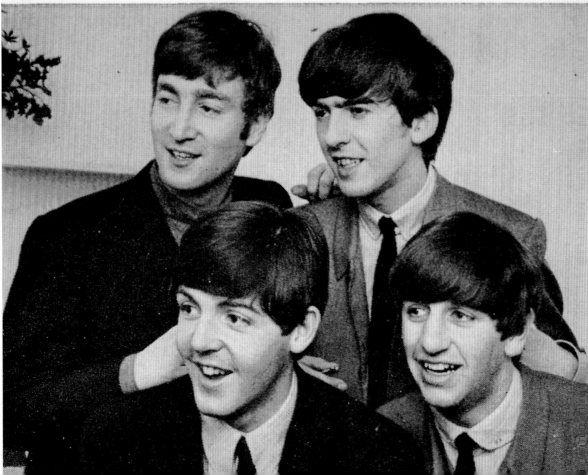

during the height of the 1964 "attack" (as did Dean Martin, Louis Armstrong, Lorne Greene of *Bonanza*, and Bobby Vinton, if the whole truth be told).

In 1965, thanks to Motown and folk-rock, the balance of power would be restored, and eventually tip back a bit in favor of the Yanks. Through all this, the moribund Elvis was of little help. The erstwhile King faced the British challenge of '64 by releasing cuts from old albums as singles (like "Such a Night" and "Ain't That Lovin' You Baby") while occasionally recording new tunes like the immortal "Kissin' Cousins"—although, to be fair, "Viva, Las Vegas" (number twenty-nine in the summer of 1964) was toe-tapping fun.

For teens, it was a long, long way from the simpering of such 1963 hits as "Candy Girl," "Blue Velvet," and "Hey Paula," praise the Lord—but rock 'n' roll held plenty of other surprises down the road, not all of them pleasant. But why bring up "Sugar, Sugar" now?

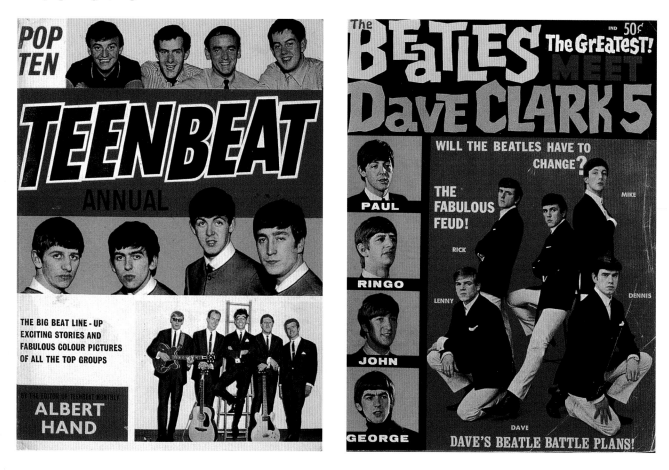

RICKY NELSON—BORN 2-B A TEENAGE IDOL

Some call him the ersatz Elvis, but those critics are selling short the pride of Teaneck, New Jersey. For one thing, Ricky Nelson was the only teen idol who got his start by bragging to a girl he was trying to impress that he could make a record as good as any of Elvis's—and then do it! And the kid was only seventeen! The record was "A Teenager's Romance," which reached number two on the charts in 1957; but it was the flip side that rocked out—a hoppin' cover of Fats Domino's "I'm Walkin'." And if anything, Ricky had a hair thing going on that was at least the equal of The King's—and we're talking the pre-dye-job King, at that. (Note that Ricky used to play touch football with Elvis, and may have been the guy who turned The King on to karate.) So what if Mom and Dad Nelson, and brother David, were L-7 squares. . . Is that Ricky's fault? (As if Elvis's folks were any cooler! At least Ozzie could play the sax.)

Granted, Ricky used an echo chamber and double-tracked his voice on "Hello Mary Lou" and other songs, and he wasn't responsible for the super guitar solos on songs like "Travelin' Man" and "It's Late" (thank you, James Burton)—but do you think for one moment that you're hearing Elvis playing instruments on any of his hits? True, Ricky remade a few too many 1940s tunes, and moved too far away from rock in favor of schlocky ballads like "Young World" as the sixties progressed. As for his acting on *The Adventures of Ozzie and Harriet*—yes, it was downright embarrassing. (On the other hand, have you ever tried to sit through Elvis's *Harum Scarum*?)

Ever since the April 10, 1957, episode of *Ozzie & Harriet*, one called "Ricky the Drummer," he was able to close the show by performing a number before a small room (his rec room?) filled with screaming teenage girls. Fair? No, probably not—a guy like Gene Vincent could have used that exposure. Buddy Holly could have used it. But only Ricky got it. Still, Ricky didn't choose his famous dad, so don't blame him.

The kicker is that Ricky Nelson was the only teen idol who had the wit to cut a record called "Teenage Idol," which detailed the tribulations of a teen rock star's lonely life on the road, reaching the top five in 1962. The song would have been almost Pirandellian in its implications if the lyrics had had anything to do with Ricky's own life. "I need somebody to be my baby/Someone to tell my troubles to/I've got no time to ever find her/'Cause I'm just passing through." Sure, like the guy wasn't fighting off the chicks with a baseball bat.

Being grounded or learning that your steady's been cheating on you may be some teenagers' definition of high tragedy, but nothing beats the tragic grandeur, the aching purity, the sheer romanticism of teen passion cut agonizingly short while still in its prime. Here are our nominations for the five greatest celebrations of the heart-rending glory of permanently interrupted puppy love:

1. "TEEN ANGEL" BY MARK DINNING; CHART HISTORY: Was #1 on Feb. 8 & Feb. 15 of 1960; CONCEPT: Making out while parked on the railroad tracks, a young couple's car gets stuck as a train approaches; MOMENT OF TRUTH: "I pulled you out, and we were safe/But you went running back...What was is you were looking for/That took your life that night? They said they found my high school ring/Clutched in your fingers ti-yi-yi-iight;" LAMENT: "Are you somewhere up above?/And are you still my own true love?"

2. "TELL LAURA I LOVE HER" BY RAY PETERSON; CHART HISTORY: Reached #7 in 1960; CONCEPT: Laura and Tommy were lovers. To buy her a wedding ring, Tommy enters a stock car race ("He was the youngest driver there") for the $1,000 prize money, leaving a message for Laura's mom: "Tell Laura I Love Her..."; MOMENT OF TRUTH: "No one knows how it happened that day/How his car overturned in flames/But as they pulled him from the twisted wreck/With his dying breath, they heard him say..."

3. "PATCHES" BY DICKIE LEE; CHART HISTORY: Hit #6 in 1962; CONCEPT: Patches comes from Shantytown, so the narrator's parents naturally force him to break up with her. She doesn't take the news well, to put it mildly: "I heard a neighbor telling my daddy/He said a girl named Patches was found/Floating face-down in that dirty old water/That runs by the coalyard in old Shantytown"; MOMENT OF TRUTH: Considering his options, the narrator decides on this grand gesture: "Patches, oh, what can I do?/I swore I'd always be true/It may not be right/But I'll join you

tonight/Patches, I'm coming to you."

4. "LAST KISS" BY J. FRANK WILSON & THE CAVALIERS;

CHART HISTORY: Reached #2 in 1964; CONCEPT: Out on a date on a dark, rainy night, the narrator swerves to avoid a stalled car and cracks up. Before he passes out, he hears his girlfriend's "painful scream"; MOMENT OF TRUTH: "I raised her head, and she smiled and said, 'Hold me darlin' for a little while.' I held her close, I kissed her—our last kiss—and found the love that I knew I would miss. And now she's gone, even though I hold her tight..."

5. "THE LEADER OF THE PACK" BY THE SHANGRI-LAS; CHART HISTORY: Hit #1 on November 28, 1964; CONCEPT: A girl meets the local star tough at a candy store and falls hard for him, but when her parents make her break up with him ("They said he came from the wrong side of town..."), he jumps on his 'cycle and peels off in white-hot fury, ignoring the rain-slick road conditions; MOMENT OF TRUTH: "Look out! Look out! Look out! LOOK OUT!!!" BEHIND THE TRAGEDY: An engineer named Joey Veneri brought his motorcycle into the recording studio to help supply the totally cool sound effects of a bike crashing head-on into a car; ABOUT THE ARTISTS: The Shangri-Las were comprised of teenage sister sets Mary and Betty Weiss and Marge and Mary Ann Ganser (who were twins), all of Andrew Jackson High School in Queens.

And One Great Close Call...

6. "ENDLESS SLEEP" BY JODY REYNOLDS; CHART HISTORY: Hit #5 in 1958; CONCEPT: After a quarrel, the narrator realizes his girlfriend has walked down to the ocean to throw herself in: "I looked at the sea, and it seemed to say/I took your baby, from you, away/I heard a voice, cryin' in the deep/Come join me, baby, from the endless sleep..." But he jumps in and saves her in the nick of time—leaving us with the most evocative of the near-miss tragedies.

Dating Do's and

"A FRANK, WISE, AND THOROUGHLY CLEAN DISCUSSION OF THE PROBLEMS OF
SEX LIVING THAT ARE FACED BY TEEN-AGERS." —*BIBLE TEACHER*

(Dust-jacket blurb for *Facts of Life and Love for Teen-agers* by Dr. Evelyn Mills Duvall, American Association of Marriage Counselors)

Oh, those "problems of sex living"! They're bad enough for us adults, but for the poor, inexperienced teen, those quandries loom larger—and scarier—than the House of Horrors at Great Adventure. What adolescent (whether willing to admit it or not) hasn't had the stuffing scared out of him or her by the mere prospect of trying to negotiate the perilous highways and byways of teenage romance?

These are rocky roads, fraught with potholes a teen rarely sees until it's too late; poorly marked, dimly lit byways that must be traversed virtually in the dark. If you're a teen, you need someone to provide a roadmap and a flashlight—guidance from above. Because, yes, that road is paved with dates. Terrifying dates. Disastrous dates. Excruciating dates, dates whose aftermath leaves you tossing and turning, night after night for weeks on end, as you deconstruct every last gaffe, blunder, and faux pas.

Is there no way to prepare for the rigors of the dating ritual? Understandably, the inexperienced teen's first reaction to the prospect of a date is, and always has been, utter panic. But not to worry, the situation quickly escalates into something worse—far, far worse. It's like this: You're on your own, and there, off in the distance (like Oz) is something called The Opposite Sex. Your

Don'ts—and Maybe's

move. Should you take advice from friends on how to meet, and win, him or her? Terrific—that advice is plentiful, and it's even free. But if those snickering wombats you call friends *really* knew anything more about the mystery of dating than you, they wouldn't be hanging out on a Saturday night talking to *you*, would they? As far as those hopelessly euphemistic lectures on the subject by parents go, they're as worthless as the paper they were never printed on. (Hard to believe that grownups ever *had* sex in the first place—but then, you're the living proof of *that*, eh?)

Do Hollywood movies provide a roadmap? Sure, guys—if you happen to have the confident swagger and irresistible looks of Rock Hudson, with behind-the-scenes coaching from a screenwriter, director, and an Oscar-winning orchestra. And the same for you, girls—unless you have the perkiness quotient of Sandra Dee, the button nose of Tuesday Weld, the soulful eyes of Natalie Wood, and the body of the young Liz Taylor, forget it.

Popular music? Now we're getting warm. Many a truth about the perilous shoals of dating lies among the lyrics of rock ditties. But the love lessons proferred in one rock 'n' roll anthem often are immediately contradicted by the message put forth by the next, quickly and surely driving mad the teen in need of guidance.

Should one's dating role model be the masochistic loser who inhabits Ricky Nelson tunes like "Stood Up" ("Why must I always be the one/Left alone, never havin' any fun?") and "Poor Little Fool" ("I used to play around with hearts/Never thought I'd see/The day when someone else would play/Love's foolish game with me")? Or should one emulate the cocky, confident Ricky of "If You Can't Rock Me" ("If you can't rock me/I'll find me somebody who can/ I'll get me another woman/And you can find another man")? Should a girl align herself emotionally with the masochistic Lesley Gore of the 1963 number-one hit "It's My Party" ("And I'll cry if I want to/You would cry, too/If it happened to you") or the defiant protagonist of her fourth hit, "You Don't Own Me" ("I'm not just one of your pretty toys/You don't own me/Don't say I can't go with other boys")?

Should the teen lad prepare to wallow in self-pity like the Dion of the 1959 "Lonely Teenager" ("I want to go back home/ Where I belong/I know I'll be all right/If I stay out of sight"), or should he adopt the pose of the strutting narrator of Dion's 1961 classic "The Wanderer" ("Now I'm the kind of guy/Who'll never settle down/I love 'em and I squeeze/'Cause to me they're all the same/I hug 'em and I tease 'em/They don't even know my name")? As each song presents its own kind of indisputable truth, is it even possible to make a choice between them? As dating guides, then,

TEENAGERS NEEDED ALL THE ADVICE they could get when it came to plumbing such eternal mysteries as Kissing (How?), Petting (How much?), and Going Steady (When and why?).

TEEN
LIFE

SEPTEMBER

Sex Facts for Teenagers

PUC 25¢

HOW TO BE POPULAR

Complete Guide To Dating

Kissing—Petting—Going Steady

Class of 1969 Haverhill High School
Post Prom Party
Friday evening, May 30, 1969 Midnight to 3 a. m.
YANKEE DOODLE RESTAURANT, LAWRENCE
Dinner ✦ Continental Sounds
$11.00 PER COUPLE

Top Forty hits are only intermittently useful: one song's lesson cancels out the wisdom of the other as fast as DJs can add them to their playlists.

No, rock 'n' roll, for all its charms and influence, cannot be counted as a reliable source of information about what to do, and—just as importantly—what *not* to do while conducting a romance. But despair not. For explicit advice that can teach the lonely or lovesick teen how to end his or her suffering in as expeditious, and socially acceptable, a manner as possible, let us now pay a visit to a very special educational genre—the quaintly charming instructional films of years past.

A medium that dates all the way back to the 1920s, these humble Instructionals (one- or two-reel shorts, generally ten to fifteen minutes in length) at first were sponsored by various industries with the goal of educating the public about a certain product or attraction—a new line of cars, for example, or the 1939 World's Fair. The forerunner of today's informercials, Instructionals expanded their range in the forties and fifties to include advocacy of certain behavioral modes that someone, somewhere, wanted to popularize—such as the adoption of safer driving techniques (a favorite of the insurance industry). Later topics memorably treated in Instructionals include how to survive an atomic attack and (almost as critical) recognizing the benefits of tranquilizers.

As teen culture began to assert itself, Instructionals were able to address a new market, one much in need of instruction. Shot with actors who make cardboard seems vivacious by comparison and who could barely walk across a room without knocking over a dinette set, these prescriptive lessons in living were screened in school assembly halls, in a presumably genuine but hopelessly misguided attempt to steer teens on a straight and narrow course. Consider the 1947 gem *Shy Guy*, with young Dick York (later to star as the befuddled husband on *Bewitched*) epitomizing the awkward, painfully introverted teen who needs to be taught the most basic techniques of interacting with the opposite sex. Clumsily staged and scripted, such vignettes elicited more snickers from their jaded, captive audiences than the makers ever could have anticipated.

What to Do on a Date, a 1951 rhinestone, was produced with the assistance of "Educational Collaborator" Evelyn M. Duvall, Ph.D.—yes, the same Evelyn Duvall who a few years later would bring *Facts of Life and Love for Teenagers* to the world. It's all about the halting efforts of one Nick Baxter to get the apple of his eye, Kay, to go out with him on a date. Nick, a nice guy for whom the term "nerdy" was surely minted, fortunately has a pal coaching him in the fine points of asking Kay out—like picking up the phone and dialing her number, for starters. Once Nick has summoned up the nerve to phone Kay, and after she has gracefully accepted his invitation to accompany him to the Scavenger Sale at the town's Community Center, the inevitable instructional film narrator butts in with the unavoidable explication of what we have just seen. "Would Kay enjoy a bike trip? Or a weenie roast? Another group date," he intones pompously; "Another chance to learn the give and take of working and playing together."

Now that Kay is working (and playing?) alongside him at the Scavenger Sale, Nick expresses amazement that she accepted his invitation. "I thought all girls wanted guys to take them to fancy places, spend lots of money," he admits shyly. "Not *this* girl," Kay is quick to reassure him. Needless to say, they have a swell time, and it is strongly implied that a lifetime of weenie roasts, swimming meets, and bake sales await them—assuming Nick remembers how to dial her phone number.

The 1952 Coronet instructional *Dating Do's and Don'ts* takes a more prosaic approach to the dating quandary. Literally a how-to, the film is broken into three segments: "How *Do* You Choose a Date?", "How *Do* You Ask for a Date?", and "How *Do* You Say Goodnight?" With the Hi-Teen Carnival employed as a common backdrop, each of those conundrums receives its own little dramatization, followed by a portentous analysis by the narrator. The first question is answered by showing that Ann receives date invitations frequently because "She knows how to have a good time—and how to make the fellow with her relax [and] have fun too." But question number two is a puzzler for poor Woody, who gets shot down repeatedly by using poor technique—too shy on one occasion, too cocky on another—until he hits it just right with Ann by being both polite and forthright.

As helpful and pervasive as such Instructionals were to teens, who watched them in uncalculable numbers as each film was screened over a period of ten or even fifteen years (three generations as far as teendom was concerned!), they could only do so much. Fortunately for teenagers ignorant in the ways of Life and Love, which basically included everyone 'twixt twelve and twenty, the adult philosophers, social critics, and general busybodies of America also provided a floodtide of books and magazines that teens could, and did, refer to for aid and abettance. Rare was the general interest magazine of the forties, fifties, or sixties that did not address one of the day's many burning teen issues every month or so. And the winners in the journalism category for "Dating Do's and Don'ts" are:

1. **"PETTING: NO. 1 PROBLEM"** (*Picture Week*, March 13, 1956): "If a sound and healthy attitude towards petting were taken by parents, so that our young people might…realize just 'how far to go,' then petting would not be so much a hush-hush, nasty activity, but the normal release of nature's strongest drive."

2. **"WHEN IS GOING STEADY IMMORAL?"** (*People Today*, August 1957): "'Each time we start to neck it gets harder to stop.' This dilemma of teenage 'steadies' has caused many parents, psychiatrists, and clergymen to regard the practice of going steady as an open invitation to immorality….Catholic theologians regard the practice as an almost inevitable cause of sin. In Lynn, Mass., the Right Rev. Monsignor Joseph McGlinchey banned going steady for students of coed St. Mary's Parochial High School with this comment: 'Going steady is a menace to the purity of our youth.'"

3. **TAKING THE OPPOSITE TACK** was *Life* magazine's June 1954 article "Going Steady," which ran with a picture of a blissfully happy teen couple from Colorado above the headline, "Teen-agers Find It Is a Happy Guarantee of Dates." The piece is quite reassuring in tone: "Though parents worry about their youngsters 'tying

Do you know how far to go?

PETTING:

DIRECT EXPRESSION of the sexual desires outside of marriage is frowned on in our society. This is a fact that is driven sharply home to our young people from the very time they begin to recognize the differences between the sexes. Despite the strong taboo that exists, there is more and more evidence that the young men and women of this country experience frequent direct sexual gratification—mainly in the form of petting and

THE OLD PARK BENCH is too often the spot where young people learn about the mysteries of our strongest drive.

What Annoys You Most on a Date?

Most of these New York City high school students tell LOOK dates are fun, but all of them have a pet peeve

Ann Flavin, 17: "It gets me down to have a fellow spend the whole date talking about himself. But if he does, I have a way of stopping him. I just say, 'So everybody's crazy about you. I can't see why!'"

Frank Cincotta, 15: "Regimentation! If you didn't have to buy her a soda, I'd get along better. The way it is, one date a week keeps me broke. I'd rather go easy on the pocketbook, and go out more often."

Nelly Magnussen, 15: "A boy named Herby! He's a character! Every time you turn around, he's pulling some corny joke. Sometimes it gets my goat. But I must like it, I keep on going out with him."

Bill Krugge, 15: "When I go out on a date, I don't like a girl that tries to be too friendly. I like to be in command. In fact, I don't take them out more than once, if they don't usually let me take the initiative."

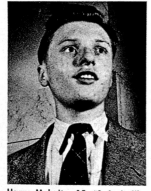

Harry Molwitz, 15: "I don't like these girls that aren't well-adjusted. Most of them either talk too much or else they don't let out a peep. I want the happy medium. You don't happen to know one?"

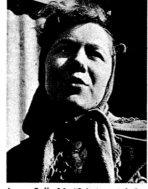

Joyce Bell, 16: "I hate not being introduced when my date meets an old friend. Sometimes you're just left standing. You can't tell whether the boy is ashamed of you, or afraid he might be going to lose you!"

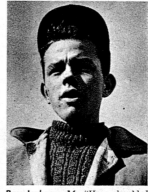

Roy Isaksen, 16: "How should I know? I've never been on a date in my life. I just don't have time for that stuff. Hey, I got it—the thing that annoys me most about a date is having to take a girl out on it!"

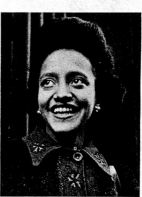

Marie Mercado, 16: "Getting stuck with the athletic type. I don't like to skate, play tennis or bowl. I'd just as soon stay home as to go out and do that. When I have a date, I want entertainment, *not* exercise!"

Rose Marie Jensen, 16: "I really enjoy every minute of a date—from the time the boy calls until he leaves me at the door. I think dates are simply terrif! The only annoying thing is that they have to end!"

John Salmond, 15: "I don't like to hear all about the girl's other guys. That annoys anyone. Also, I don't want her to be too serious. You know what I mean—like discussing relativity or anything like that!"

Lorraine Houghton, 15: "It's not the date itself that bothers me. Meeting the boy friend's parents is what gets me upset. The way they look at you makes you feel like you were a wild animal or something!"

Bill Simpson, 16: "I'm usually on edge about money. Sometimes I break out in a sweat thinking I haven't got enough money for the bill. Once that happened and I had to borrow a nickel from the girl."

themselves down' too early...Denver's Judge Phillip Gilliam, an authority on family problems, observes, 'Many marriages fail because young people don't take the time to know each other. Going steady gives them this chance—and gives parents a chance to know the youngsters.'"

4. "WHAT TO TELL YOUR TEEN-AGE DAUGHTER ABOUT SEX," from *Cosmopolitan's* June 1951 issue:

Your daughter is fourteen....She is aware of feelings she never had before and cannot understand. Social standards have changed—often for the worse. There are still an amazing number of youngsters who have gleaned their information and misinformation from each other, and to whom sex is still a subject for embarrassed whispering.

QUESTION: "All the boys say there is nothing to do after a party but pet."
ANSWER: Trivial sex experience may dull your capacity for truly great love.... The more you pet, the more your body clamors for closer union."
QUESTION: "Boys say they don't want their wives to be virgins anymore. That's all out of date now, Mother."
ANSWER: "The sex act is often painful at first and not pleasurable at all.... Therefore if you have sexual intercourse at an early age you may be frightened and disgusted by it—and never marry."

5. *LOOK* MAGAZINE'S PAIR OF "MEET THE PEOPLE" Q&A'S, "How Much Should a Boy Spend on a Date?" (December 14, 1943) and "What Annoys You Most on a Date?" (April 1, 1947). The first Q&A found guest interviewer Kate Smith canvassing the student body of St. Louis's Beaumont High School, where she heard responses ranging from $7.00 ("For a big evening") to $3.00 ("You can always have a good time on that") to $1.00 to 30 cents ("Often two sodas is enough"). The latter Q&A finds a dozen assorted New York City high school students expressing their pet peeves about dating. These included: meeting the boy's parents; guys who make corny jokes; "getting stuck with the athletic type"; discussions about serious topics ("you know—like relativity!"); girls who talk too much; not being introduced when the date meets an old friend; spending money of any sort, even for a soda; girls who don't let the guy take the initiative; and this comment from sixteen-year-old Roy Isaksen—"How should I know? I've never been on a date in my life. I just don't have time for that stuff."

6. *LADIES HOME JOURNAL'S* 1949 INVESTIGATION "WHERE DO TEEN-AGERS GET THEIR SEX EDUCATION?" posited that "most teen-agers *do not* get information about sex from their parents." As one interviewee put it, "Everybody picks up a lot of information from dirty talk. After that you just have to fill in things for yourself." This survey was just one of twelve installments in the "Profiles of Youth" series the magazine ran that year. The same issue posed the less weighty but no less fascinating question, "What Makes a Perfect Teen-ager?" It included a photo-demo of "The Perfect Good-Night Kiss" ("Ten seconds—not too hard, not too long"), as well as explication of a survey that found "Boys Like Cheap Dates." "The most

fun I ever had was on a picnic with my girl. We climbed a fire tower, danced in the grass, didn't spend a dime."

7. *LOOK*'S 1949 "BEHAVIOR IN COURTSHIP" STUDY, which helpfully provides "Ten Rules for Courtship Behavior," a few of which are:

1. Be yourself—not what you think he wants you to be.

6. Find out how he feels about children, a home, religion, and money.

8. Avoid intimate physical relations before your marriage.

10. To eliminate doubts and fears, seek the guidance of qualified counsellors on marriage.

Dr. Evelyn Mills Duvall's *Facts of Life and Love for Teen-agers: New Revised Edition*, described by no less an authority than the *New York Times* as a "sane, sound, reassuring book [that] minces no words," is a fount of fifties-style wisdom about both the etiquette and the ethics of dating and relationships. A partial list of the book's chapter headings includes "Becoming More Datable," "Sex—Problem or Promise?" "What Boys and Girls Expect of Each Other," "Do You Have to Pet to Be Popular?" "How to Say No," "How Late Should a Date Last?", "How to Accept a Date," "Reasons for Going Steady," and "When an Engagement Must Be Broken." Some of the chapters from *Facts* were reprinted in the indispensable 1959 one-shot magazine *Teen Life*, which also drew from such tasty tomes as the ubiquitous Duvall's *The Art of Dating* and Alvena Burnite's *Tips for Teens on Love, Sex, and Marriage*.

The equally wide-ranging 1954 tome *How to Be a Successful Teenager* is a collection of essays by a variety of family life experts from around the country. In "Dating Tips" by Lester A. Kirkendall and Ruth Farnham Osborne, we find that "Boys are attracted by a peppy, wide-awake person who likes to have fun" (the Sandra Dee factor), while "Girls prefer boys who ordinarily are polite and who fit into a group reasonably well" (thus, James Dean need not apply). The authors also provide a helpful checklist for each sex to examine before they proceed with a date. Among the points they suggest girls ponder are "Do you appreciate the fact that a car is less important than the boy himself?" and "Are you intelligently interested in the world around you?" For boys, the queries include "Do you keep your voice pleasant-sounding on a date?" and "Can you converse on subjects other than football and cars?"

Of course, only the most motivated of teens would make the effort to locate, acquire, and study such tomes in the first place. For the most part, information (or misinformation) about the ins and outs of dating and the perils of going steady would come from the flotsam and jetsam of mass teen culture. And it is among the jetsam that we find one more crucial source of dating info—that universally accessible, infinitely dispensible, perniciously pervasive form of cheap entertainment, the comic book.

ROMANCE COMIC BOOKS
were introduced in 1947, and quickly caught on with readers who enjoyed these endless variations about love's often bitter lessons.

Not that most of the early comics had much to do with either teenagers or dating. There was of course Frank King's brilliant newspaper strip *Gasoline Alley*, which took a dramatic turn on Valentine's Day in 1921.

It's then that Walt Wallet finds an infant in a basket on his doorstep. The child, whom Walt names Skeezix, soon becomes the strip's leading light. And as the years go by, Skeezix grows to become a full-fledged teen (the strip was unique in employing a "real-time" framework for its characters to exist, and age, within). Skeezix begins to successfully carry on a fumbling but heartfelt courtship of future bride Nina Clock. In one typically effective two-month sequence late in 1938, Skeezix has a spat with Nina over another girl's interest in him and spends the next several weeks in emotional purgatory, alternately suffering from jealousy as she dates a hulking football player and vainly trying to make her jealous by pretending to be interested in other girls.

In the course of those nine weeks of daily *Gasoline Alley* strips, more territory is covered concerning the imperatives of the adolescent psyche than any three textbooks could hope to provide. And while Skeezix's only real vice was tooling around town in his run-down jalopy with his equally benign pals, it was a sign of things to come that Skeezix and Nina graduated from high school in 1939—right on the eve of America's coming-out party for that newly self-aware teenage subculture.

Romance, or "love" stories, presented in a confessional mode, had long been a staple of the pulp magazines; in 1947, the creative team of Joe Simon and Jack Kirby (famed for such superhero creations as *Captain America*) cooked up a comic book called *My Date*. The first issue, dated March 1947, led off with a comical story about a teenage inventor named Swifty Chase and his girlfriend, Sunny Daye, but the other stories in each issue of *My Date* treated romantic issues in a

comparatively serious (not to say melodramatic) vein. This was an innovation for the staid world of the mid-forties comic book.

When the positive letters poured in from appreciative readers, Simon and Kirby immediately set about creating a comic book "designed for the more adult

readers of comics"—i.e., teens. The result was *Young Romance*, which from the first issue in September of 1947 boldly focused on the pitfalls of love. One of the stories in that debut issue, "I Was a Pick-up," sent the clear message that we were not in Riverdale anymore, Toto.

The decision to ditch the "comic" part of the comic book format in order to serve up undiluted passion plays turned out to be a stroke of genius. *Young Romance* quickly took the volatile comic book industry by storm. Within eighteen months, a veritable horde of competitive titles had made their way onto news-stand racks. Looking at just two letters of the alphabet, we find such titles represented as *Love Adventures, Love at First Sight, Love Classics, Love Confessions, Love Diary, Love Dramas, Love Experiences, Loveland, Love Lessons, Love Memories, Love Mystery, Love Problems* and *Advice Illustrated, Lovers Lane, Love Scandals, Love Secrets, Love Tales, Love Trails, My Desire, My Diary, My Great Love, My Intimate Affair, My Love, My Love Story, My Private Life* and *My Secret Life*, all of which were on comic book racks by 1950. This category prolif-erated with such success throughout the fifties that, inevitably, it overwhelmed— and in several cases permanently displaced—many of the character-driven teen titles. (Archie and his gang's own titles remained inviolate, however.) Nor were these little morality tales always polite, with provocative covers and stories with racy titles like "They Called Me Cheap," "Men Didn't Respect Me," "He Ruined My Future," "Men Gave Me Jewels," and "Honeymoon without Love."

The stories in this first wave of Love comics were not overtly *about* teens; instead, they focused on the pre- and post-marital tribulations of young adults. But the appeal of these magazines was overwhelmingly targeted toward teenagers. (*Real* young adults presumably had better things to do with their lives than read ten-cent fantasies about their romantic crises.) It only made sense that, soon enough, Love comics filled with prescriptive tales—often billed as being "true" or "real-life"—about genuine teen characters were being created: *Hi-School Romance, Teen-Age Diary Secrets, Teen-Age Brides, Teen-Age Romances, Teen-Age*

Temptations. Many of these offered pithy lessons on dating behavior that teens could ignore at their own peril. *Hi-School Romance* #2 (December 1950) covered quite a bit of territory: "I Had to Share My Boyfriend," "Love Isn't Funny" (absolutely true, we all can agree), and "Phantom Lover." The invaluable text departments, with pros and cons submitted by readers, included "How Do You Rate on a Date?", "I Fell in Love with My History Teacher," and "Should High-School Students Go Steady?"

Teen-Age Romances #38 (July 1954) was also formidable, with stories like "I Threw Away My Reputation on a Worthless Love," "Two-Timing Taught Me to Love" ("I was fed up with penny-ante dates...."), "I Talked Myself into Love Troubles," and "My Double Life Caught up with Me" ("I thought it would be fun to run with a fast crowd...."). *Boy Meets Girl* #3 (June 1950), too, had a wealth of wisdom to offer: "Perhaps to Dream," "Romance on My Doorstep," "Love on Trial," and "A Dress for Mary." It also offered the text feature, "The Most Romantic Moment in My Life," submitted by reader Mrs. Davis Dennis of La Carne, Ohio, who was sent a $10.00 check for sharing her story.

Young Love #3 (June-July 1949) presented "Headstrong," "Wallflower," "Clinging Vine," "Matchmakers," and the useful department "Nancy Hale's Problem Clinic"; the problem of the month was "Whether or not to take a drink on parties and dates." (The answer may surprise you!) And *First Love* #1 (February 1949) had a strong lineup with "Party Girl," "Dream Date," "She Didn't Ask for

AT THEIR HEIGHT OF POPULARITY
in the early fifties, there were no
fewer than eighty different love comic
titles appearing every month on
the nation's newsstands.

Love," "A Girl Leaves Home," and (whew!) "Dateless." The feature "Cupid's Corner" provided choice excerpts from the poetry of Robert Burns, Thomas Moore, and that dating fool, Edgar Allan Poe.

Romance comics flourished throughout the fifties and into the sixties, but as that decade drew to a close, readership fell off. A few titles straggled into the seventies, but it was a losing battle. What had once been the flagship genre of the comic book industry petered out to an ignominious end, finishing not with a bang but with a whimpering sob. What did teens, particularly female teens, find to replace their Love comics? Television soap operas? Paperback romance novels from Harlequin and other specialty publishers? Hashish? Your guess is as good as ours—better, perhaps, if you've ever loved and lost.

How's Your

EVERY SUBCULTURE HAS ITS CODE, AND EVERY TRIBE ITS RITUALS. BUT WHO EVER DID IT BETTER THAN THE AMERICAN TEEN? The hair, the clothes, the slang, the games, the totems—all as cool as cool can get. Of course, there were different guidebooks for different castes, since being a teen in the forties, fifties, or sixties was hardly a monolithic enterprise.

For KleenTeen girls, guidance came each month from *Seventeen* and *Ingenue* magazines, along with a wide range of supporting manuals. For the girls who didn't aspire to become teenage gang debs, it was hard to beat Mary Sue Miller's 1960 classic *Here's to You, Miss Teen!—A Guide to Good Grooming and Poise*, which included chapters on "Teenliness" (with the critical Manners Code for dating, telephoning, family functions and dances); "What Are You Going to Wear?" (with Fad Fashions and Fashion Taboos and Shortcuts to Shopping); "Complexion Perfection"; and "Cut a Good Figure" (with the Fine Points of Carriage complemented by Tips on Gaining and Losing Weight).

Guys had a little tougher time of it, but in the late fifties unisex help was provided by the invaluable *Cool* and *Dig* magazines, which recognized that *real* guys wouldn't be embarrassed to admit that, once in a while, a fellow needed some help, too. Service articles like "How to Give a Successful Platter Party," "Are You Grown Up?", "Do You Know How to Kiss?" (all from *Cool*'s March 1958 issue), along with tips on getting that duck's-ass haircut *just* right, helped keep things civilized. (How much can a guy learn about girls from *Hot Rod* magazine, anyway?) What follows are selected highlights from these and other arbiters of teen fads and teen fashion.

Slanguage?

HOW'S YOUR

Are you "hip" to today's lingo? Below are terms used by youth, "Man Crazy," a Twentieth Century-Fox release. Se are jumbled in th

Irene Anders, Christine White and Coleen Miller are the lovely young starring trio of "Man Crazy." It is today's most searching story written in shame and shock, tears and tragedy, truth and terror! Don't Miss It!!

1. Square

2. Crazy

3. Go-Man-Go

4. Send

5. Hip

6. Cool

7. Bop

8. Hot-Rod

ANSWERS

8. Y

7. Z

6. A

5. R

4. C

3. N

2. A

1. M

SLANGUAGE'?

nagers in the bold and searching new drama of today's
ou can match them correctly with their definitions, which
on the right.

uperlative

Inspire To

failure

rge on

ware

river of a
epped-up car

odern Music Form

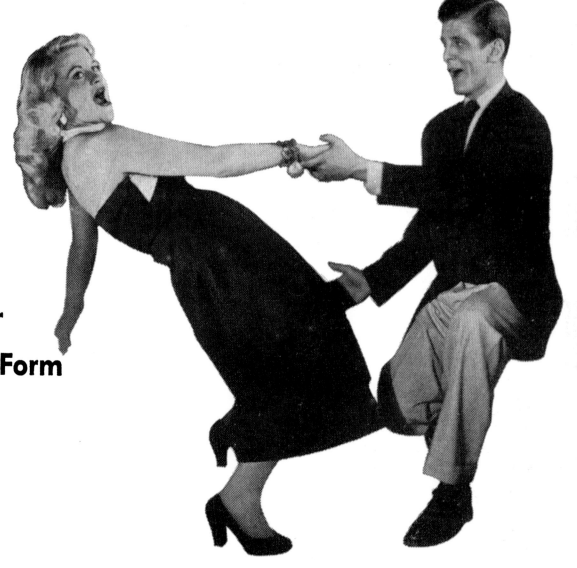

T H E A T R E

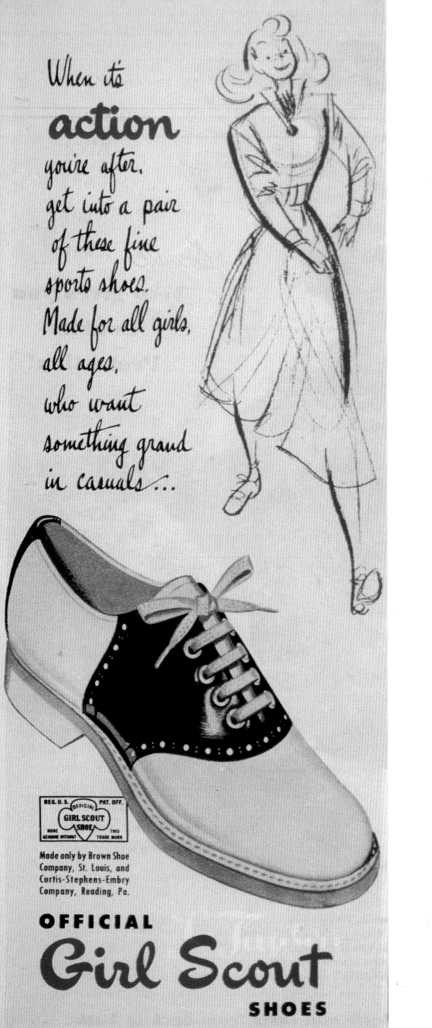

When it's **action** you're after, get into a pair of these fine sports shoes. Made for all girls, all ages, who want something grand in casuals...

REG. U.S. PAT. OFF.
OFFICIAL
GIRL SCOUT SHOE
NONE GENUINE WITHOUT THIS TRADE MARK

Made only by Brown Shoe Company, St. Louis, and Curtis-Stephens-Embry Company, Reading, Pa.

OFFICIAL
Girl Scout
SHOES

It is not an official shoe unless it is marked "Girl Scout"

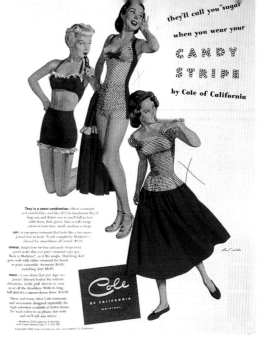

they'll call you "sugar" when you wear your
CANDY STRIPE
by Cole of California

They're a sweet combination—these swimsuits and matchables—and like all Cole beachwear they'll hug you and flatter you so you'll fall in love with them. Red, green, blue or taffy beige cotton in teen sizes: small, medium or large.

LEFT: A one-piece swimsuit that looks like a two-piece. Joined low in back. Trunk completely Matletex*—shirred for smoothness all 'round. $9.95.

CENTER: Smart bow-tie bra and candy stripe front panel make this one-piece swimsuit very gay. Back is Matletex*, so it fits snugly. Matching skirt goes well with either swimsuit for beach or patio ensemble. Swimsuit $9.95, matching skirt $8.95.

RIGHT: A sun dress that just zips on—presto! Shirred bodice fits without alterations. Little puff sleeves to wear on or off the shoulders. With its long, full skirt it's a square-dance dress $14.95.

These and many other Cole swimsuits and accessories designed especially for high-schoolers available at better stores. No mail order to us please, but write and we'll tell you where.

*Matletex, Cole's patent of shirring with Lastex thread. Reg. U.S. Pat. Off.

Copyright 1949, Cole of California, Inc., Los Angeles 13, California.

Cole OF CALIFORNIA ORIGINAL

PIMPLES
dry up in 3 days
OR YOUR MONEY BACK!

At last science has discovered a fast, harmless way to clear your skin of those horrible pimples, blackheads and acne spots. This is an entirely new, greaseless cream that contains powerful A and D vitamins. It works fast by drying out the superfluous skin oils pimples feed on...at the same time counteracts by antiseptic action, the growth of bacteria that cause and spread ugly skin blemishes.

IMPROVE YOUR APPEARANCE WITH FIRST APPLICATION

You look better the minute you apply wonder-working CLEAR-X, because its amazing skin color hides the blemishes while its medicinal action gets to work clearing them up fast. You don't risk a penny. Get CLEAR-X by sending in the coupon now, use it for 3 days, and if your skin troubles are not definitely improved, you pay nothing.

READER'S DIGEST reports amazing results from the CLEAR-X type of treatment. Experiments by a great medical college on 100 men, women and young people showed improvements in every case.

FREE IF YOU ACT NOW! A $3.00 jar of CLEAR-X medicated soap to help CLEAR-X work even faster with double action. That's a $6.00 value for just $2.98.

LOVE CAN BE YOURS AGAIN!

You can't blame him (or her) for not wanting to kiss you if your skin is oily, defaced with ugly pimples, blackheads and acne spots. Give yourself a break! CLEAR-X will clear your skin like magic!

MAIL COUPON NOW and be happy

CLEAR-X Products, Dept. 29C
270 Park Avenue, New York, N. Y.

Send me at once the marvelous new CLEAR-X formulation as per your money-back guarantee.

☐ I enclose $2.98. Send postpaid. (I save 55c mail charges.)
☐ Send C.O.D. I'll pay postman $2.98 plus C.O.D. charges.

NAME.........................
ADDRESS.......................
CITY.............ZONE.....STATE.......
☐ I enclose $6. Rush triple size (I save $3).
No COD's for Foreign & APO's

Young America "At Home" With Masland Broadloom Rugs

"Today began when we were Seventeen"

Who'd imagine all this started with a fraternity pin? It meant much wishing and waiting. But the white wedding came true. A home of our own, too! Everything had to be just right for us. That's when our Imperial Argonne Rug came into the picture. It just had to! The whole room was planned around the luxurious-looking Argonne. We're so proud of it... and so pleased to know its all-wool pile and latex back will last a long, long time. What's more, we could afford it right away. Why not add to your dream life by sending for "Young America at Home" booklet? C. H. Masland & Sons, Dept. SV-2, Carlisle, Pa.

Illustrated is Masland Imperial Argonne No. 2

MASLAND **Imperial ARGONNE**
BROADLOOM RUG

COMMON TEENAGE EXPRESSIONS

BEFORE TEENS LEARN TO WALK THE WALK, THEY MUST LEARN HOW TO TALK
THE TALK. HERE IS A SELECTION FROM SOME OF THE DAY'S BEST GUIDES

"TEEN-AGE GANGS SPEAK STRANGE TONGUE"

BOP	to fight
BOPPING CLUB	a fighting gang
CHEESY	traitorous
COOL	an uneasy armistice
COOLIE	non-gang boy
COOL IT!	take it easy!
DEBS	girl affiliates of gang boys
DIDDLEY BOP	first-class gang fighter
DROP A DIME	give me a dime
DUKE	to fight (with fists)
GIG	a party
GO DOWN	to attack another gang, to declare war
HEART	courage
JAP	to ambush or attack an individual
JITTERBUG	to fight
MEET	a meeting, usually of gang chiefs
POT	narcotics
PUNK OUT	display cowardice
RANK	to insult (usually profanity concerning a boy's mother)
REP	reputation, usually fighting reputation
RUMBLE	gang fight
SHIN BATTLE	intra-gang practice or test-of-mettle fight among gang members
SHUFFLE	to engage in a fist fight
SNAG	to attack an individual
SNEAKY PETE	cheap wine
SOUND	talk
STENJER	alpine-style hat with narrow brim
SWING WITH A GANG	to be a gang member
TIGHT	friendly, as between gangs
TO SOUND	to joke or needle

(The New York Times *special reprint of Harrison Salisbury's*
"The Shook-Up Generation," March 24-30, 1958)

"THE HISPSTER'S DICTIONARY" BY ELAINE COFFIN & RUSTY MINUTE

A.B.C.	always be cool
ACE	1. a one-dollar bill 2. an important cat
AIR	answer
ALL SHOOK	really excited about something
ALL WASTED	not with it
APE	cook, crazy, terrif
APPLE	a square
BAD	means good fitting, suitable
BAD-DAD	a cat who thinks he's so rough and tough…but nobody else does
BADGE BANDITS	policemen
BAIL OUT	to peel out from a traffic light or around a corner
BARK	money
BASH	a ball, a real good time
BATCH OUT	take off from a dead stop
BATS	a creep
BEAST	a real fast car
BIG DADDY	listen to me, kat (or kitten)!
BIG GEORGE	a quarter
BLAST	terrific
BOAST TOASTIE	a very conceited gal
BOAT	a car
BOMB	a car
BOY SCOUTS	state police
BREAD	money
BRICKS	schoolbooks
BUG OUT	to drive away fast
BURY YOURSELF	get lost
CAN	a hot-rod
CELL BLOCK	any room in a school
CHAIN GANG	a bunch of students following a teacher; squares
CHALK	a cigarette

(Cool "Magazine for Hipsters," *March 1958*)

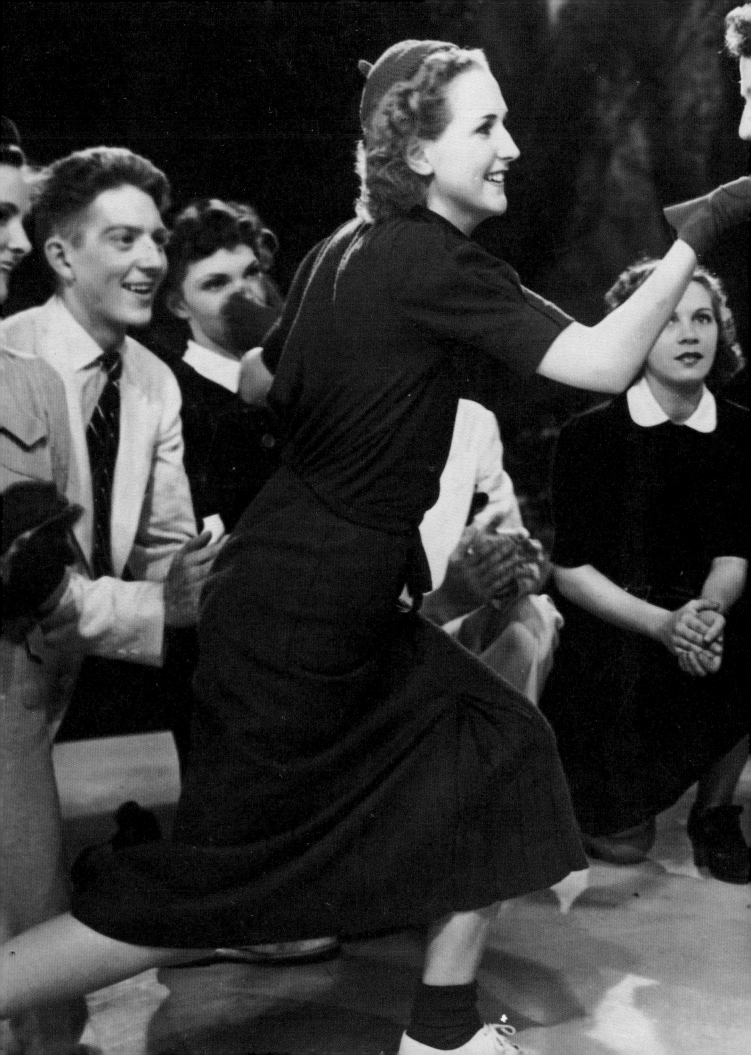

EBONY SONG PARADE'S "GET HIP" COLUMN, AUGUST 1956

BOX	piano, house, room, apartment
CONKPIECE	the head
COP A SQUAT	to sit down
DAVY CROCKETTS	draft board officials
DEEP SIX	a grave
FINE DINNER	an attractive female
FISH HOOKS	fingers
GATOR	a swing music fan
GIMS	the eyes
GOO	food, dinner
GROUND GRABBERS	shoes, feet
HARD SPIEL	jive talk
HARLEM TOOTHPICK	pocket knife
HINGES	elbows
IDEA POT	head

JIM LOWE'S "ROCK 'N ROLL DICTIONARY"

SQUARE	anyone without sideburns
HOT ROD	transportation device useful in scaring pedestrians
A DRAG	paying for things
COOL	Elvis
GONE	Elvis after being paid
FLIPPED	Elvis counting his money
HIP	hep
WILD	unusual
CRAZY	very good
BAD	good
CHICK	female of the species (at least the rock 'n roll species)
CUBE	very square
DIG	understand, see, like
SOLID	a hip chick with an empty head
STACKED	a perfect architectural structure (living)
CREAM PUFF	a car with fenders
ALAN FREED	rock 'n roll Pied Piper
CADILLAC	big man on campus

(Rock & Roll Stars #2, 1957)

TOP 20 AMERICAN TEEN CULTURE MAGS

1	COOL	"Magazine for Hipsters"; America's Coolest Teenage Mag"	Debut: April 1957
2	DATEBOOK	"The *Only* Mag That Toured with the Beatles!"	Debut: Sept. 1957
3	DIG	"For Teenagers Only": "How to Form a Car Club"	Debut: Nov. 1955
4	FLIP	"Are Summer Romances Doomed?"	Debut: Sept. 1964
5	HEP CATS	"Open Letter to Our Parents"	Debut: Feb. 1957
6	HULLABALOO	"Herman's Horrible Day"	Debut: Oct. 1966
7	JUKE BOX STARS	"Who's Behind the Bandstand Buddies Feud?" (becomes *Teen Hop*, Aug. 1960)	Debut: Aug. 1959
8	MODERN TEEN	"For Boys Only: Why Girls Are 'Different'"	Debut: June 1957
9	MOVIE TEEN ILLUSTRATED	"Is Ricky Fickle?"; "Beware of the Fabian Death Ray"	Debut: 1957
10	RECORD HOP STARS	"'The Girls I Met in Europe' by Paul Anka"	Debut: Jan. 1960
11	RHYTHM AND BLUES	"The Lymon Name Spells Fame as Frankie & Lewis Stake a Claim"; "Let's Meet Miss Aretha Franklin"	Debut: Aug. 1952
12	ROCK AND ROLL ROUNDUP	"An Open Letter to Elvis Presley"	Debut: Jan. 1957
13	ROCK 'N' ROLL STARS	"Elvis: In the Army?"	Debut: 1956
14	SEVENTEEN MAGAZINE	"Why Don't Parents Grow Up?"	Debut: Sept. 1944
15	SIXTEEN (16) MAGAZINE	"Johnny Crawford: Is He Finished?"	Debut: May 1957
16	'TEEN	"What Price Popularity? Do You Have to Lower Your Standards?"; "Do Teen Stars Believe in God?"	Debut: June 1957
17	TEEN LIFE	"Tabulating Tab Hunter"; "Booming Pat Boone"	Debut: April 1957
18	TEEN SCREEN	"What Bob Wagner Has Done to Natalie!"; "Don't Doubt Dion"	Debut: Dec. 1959
19	TEENVILLE	"10 Unusual Suggestions on How to Break the Ice"	Debut: July 1960
20	TIGER BEAT	"Cher's Sister Talks! A Visit with Georgeann Lapiere"	Debut: Sept. 1965

America's love affair with its high schools dates back at least to the 1930s, when FDR's aid to kids in the form of the National Youth Administration (NYA) began to cut into the scary statistic that over a million teenagers of high school age during the Depression weren't able to, or simply didn't, attend high school. By 1940, things had turned around sufficiently so that fully half of the seventeen-year-olds in America were high school graduates—and enrollment itself was up more than a thousand percent over 1890, when only 6.7 percent of teens attended high schools. The number of schools also had grown dramatically over that time—there were 14,300 high schools in 1920; 25,400 by 1938; and some 30,000 by 1945.

In a self-congratulatory mood, the press began to pat America on the back. *Look* magazine was as reliable an index of America's mood as any. In its July 29, 1941, issue, there was a cheery piece, "High School Kids Cut Loose!" that detailed two California high schools' jitterbug & jive contests. "*Look* Goes to a High-School Football Weekend" (November 18, 1941) took readers on a tour of upstate New York's Whitehall High School team, trying to keep its three-year undefeated streak intact (they tied, 0-0, to their anguish). "High-School Girl—1942 Model" in the April 21, 1942, issue of *Look* zoomed in on perky-but-brilliant Diana Sherman, a senior at New Rochelle's Isaac Young High School who's a chemistry major, a basketball player, works on the school paper, wears saddle shoes, doesn't smoke or drink, and "is always dated up."

Look's June 12, 1945, issue created a faux high school yearbook, complete with photos and inscriptions "for a typical senior about to graduate into war." Garden City, New York student Bill Olson was used as the model synthesized into a "typical" teenager for their spread. The teen-conscious *Look* offered another slice-of-life piece, "Texas, Where They Dance," in its April 1, 1947, issue, profiling Fort Worth's Pascal High School and its senior-class prom. Here we find senior knockout Edna Louise "Bugs" Kuhn doing the jitterbug, playing the peanut game (racing against others to push a peanut across the floor to the finish line using only your nose), and kissing her beau, Ed, goodnight (they eloped four days later!). Real KleenTeen stuff—pushing peanuts around on prom night, fer gosh sakes!—but the news from the high school crowd wouldn't remain quite that sunny as the decade turned.

Life magazine's December 14, 1953, issue inaugurated an exhaustive series entitled "U.S. Public High Schools," with Davenport (Iowa) High School the focus of the first installment. It was even-handed

enough, but just five years later—in the wake of *The Blackboard Jungle*, the advent of rock 'n' roll, and the shock of Sputnik—*Life* constructed an in-depth series called "Crisis in Education," which was cover-featured on the March 24, 1958, issue. Its first part used a point/counterpoint structure to compare and contrast Russian student Alexi Kutzkov of Moscow with his American counterpart, Stephen Lapekas of Chicago. Poor Stephen never had a chance. *Life* found that U.S. students have too relaxed an environment at school— "It's Time to Close Our Carnival" blared one headline in the article. "To Revitalize America's Educational Dream We Must Stop Kowtowing to the Mediocre" was another. Their recent article about a group of Glendale, California, high-school students who had formed a club called the Rocket Research Society now seemed like whistling in the dark.

Even that call to alarm wasn't really as scary as *Life*'s February 10, 1958, coverage of the principal at John Marshall Junior High in Brooklyn, who committed suicide by jumping off the roof of the school, in the wake of a grand jury investigation into violence under his watch (a thirteen-year-old girl had recently been raped on the premises). In the years to come, the news wouldn't get a whole lot better; space race or no space race, JFK or no JFK, and Duck-and-Cover drills aside, high-school life would always continue on apace, constantly renewing itself—like crops being rotated, only without the fertilizer. In the pages that follow, we offer some memories of the way we were— when we weren't in detention, that is.

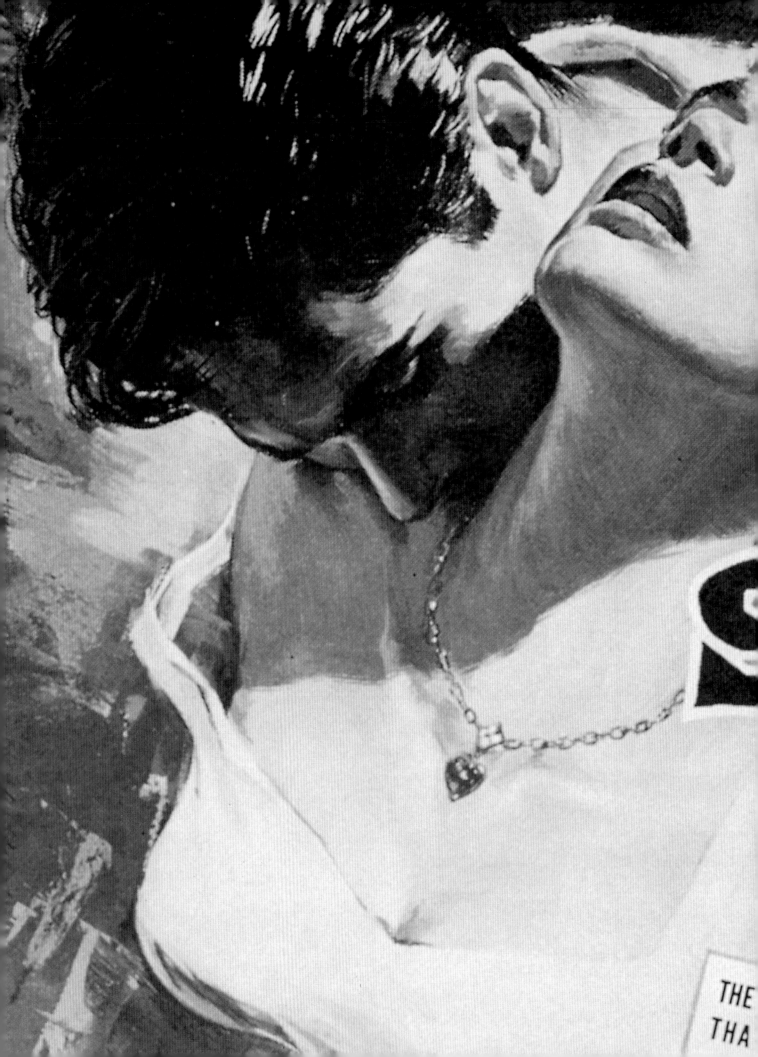

THE
THA

...what must a
good girl say
to "belong"?

HIGH
SCHOOL
HELLCATS

S ABOUT THE TARO...

A Better Greenville High School...

My every action and thought has been centered in this focal area for the past four years...I have had no selfish motives.

Most of you are beginning to realize that this is my goal. Some few of you think I am "too strict"; however, I feel certain that the vast majority of you want the same thing that I do...A BETTER GREENVILLE HIGH SCHOOL! You have shown me this the past year.

Naturally, I would cherish your personal friendship...but may I hasten to add that I would appreciate your personal admiration more...The thing that matters most to me is WHAT YOU THINK OF ME TEN, TWENTY, AND THIRTY YEARS FROM NOW! This is the big test of the job I am trying to do.

Cordially yours,

Dr. John A. Scarborough, Principal

(From the 1959 Boomerang Yearbook of Greenville High School, Greenville, Alabama

It would require another entire volume (now *there's* an idea!) to cover the next thirty years of American teenage culture—the music, movies, television shows, books and magazines, fashions, and other pop culture manisfestations of (or about) a teenager's life that evolved from the three decades we have just explored in *Teenage Confidential*! Permit us, then, simply to touch on a few of the momentous developments that became part of the woof and weave of those who lived through their teenage years from the late sixties 'til now.

In music, the Beatles passed through the teen-idol stage and into something far more wonderful and strange, but their hullabaloo splintered off into the short-lived frenzy of The Monkees, the smoldering insouciance of Jim Morrison and The Doors, and the peppy ballads of The Carpenters. Soul music annexed a significant portion of pop music's domain, with the Motown Sound of The Supremes and the Memphis Sound of Otis Redding evolving into the Philly Sound, the polish of Earth, Wind, and Fire, and on into Disco and Funk. The McCartney-lite band Wings, the megastardom of the reinvented Bee Gees, the naughtiness of Donna Summer, the flash of Elton John, the knowing cynicism of The Eagles, the inventive craft of Fleetwood Mac, the cool techno-pop of Blondie: all had their day, and then some. Hell, Kiss is already enjoying its *comeback* as we write this, and we thought they just got here!

The Jackson Five had opened the seventies with a number-one hit before Michael even *was* a teenager,

but he went on to rule the eighties as a solo performer, the biggest in the world since the heydays of Elvis and the Beatles. Some erstwhile teen idols had died in the meantime—Ricky Nelson, Elvis, Jim Morrison, Mama Cass of the Mamas and Papas—while others, like Jerry Lee Lewis and Chuck ("My Ding-A-Ling") Berry, staggered on. (Sometimes it was hard to tell which state was worse.) Of Madonna, Prince, Whitney Houston, and George Michael, among other teen idols who emerged in the eighties, suffice it to say that they have now entered their *second* decade of superstardom, thus dating both themselves (having lasted longer than the Beatles were together) and all of us (who still think of them as pop-star upstarts).

In movies, there was George Lucas's insightful *American Graffiti* (which soon would be spun-off and dumbed-down into the television series *Happy Days*), set in 1962 southern California the summer after high-school graduation; that surprisingly enduring relic from the disco era, *Saturday Night Fever*, starring John Travolta at his most cocky; the calculated fifties-homage *Grease*, with Travolta having doffed his white-on-white duds in favor of black leather and Brylcreem; *Foxes*, featuring Jodie Foster in the latter stages of her jail-bait phase.

Writer Cameron Crowe and director Amy Heckerling fashioned a hilariously right-on portrait of a California high school in *Fast Times at Ridgemont High*, including that indelible scene of Sean Penn debating history teacher Ray Walston about the constitutionality of having a pizza delivered during class;

the sweet *Sixteen Candles* and the pretentious *The Breakfast Club*, both starring Molly Ringwald and directed by John Hughes; the underrated *Valley Girl*, starring an endearing pre-Oscar Nicholas Cage; *Tex*, *Rumblefish*, and *The Outsiders*, the lesser-seen Matt Dillon trilogy based on three of S. E. Hinton's popular young-adult novels; *Porky's*, set in 1954 but stuffed to the gills with leering eighties humor about teenage sex. Most recently we were able to enjoy the sublime *Clueless*, with Alicia Silverstone a delight as a latter-day version of Jane Austen's Emma in (yet again!) a caste-conscious California high school, demonstrating that the teen-pic genre still has plenty of life left in it when presented properly—and always will, we maintain.

The same goes for such television shows of the past fifteen years as *The Wonder Years*, *Square Pegs*, *Beverly Hills 90210*, *My So-Called Life*, and *Clueless*. Although the respective quality level of these shows varies enormously, can anyone state in good conscience that the cause of teenagers nationwide has not been furthered by the very existence of such programs?

As further evidence that teen culture shows no signs of diminishing as a source of mystery—and con-

tinuing concern—to grownups everywhere, take note of the headlines from newspapers in 1996 that echoed many of the very problems involving wayward youth that first made themselves evident in the press a half-century ago. Consider *Parade*'s cover story entitled, "What Teenagers Say About Morality, Taking Drugs, Drinking, Having Sex, Making a Family, Their Future, Crime, and More" (August 18, 1996). And *USA Weekend*'s story, "When Teens Judge Each Other," about Teen Court night in Santa Fe, New Mexico, where teenagers judge each other for misdemeanor offenses; the article, which ran on October 18, 1996, goes on to note that there are currently 270 such courts in operation around the country. And *USA Today*'s cover story of August 6, 1996, "Teen Crime Tosses Ball to Parent's Court," which notes the trend toward "parental responsibility laws [that] broaden judges' discretion, making parents pay for the cost of juvenile detention.... [Some judges] threaten to lock up parents who can't control their kids." (Shades of that 1944 screen chestnut, *I Accuse My Parents!*) All of which simply goes to show that, just like our grandparents solemnly advised us, the more things change, the more they remain the same.

And they always will, as long as there are kids 'twixt twelve and twenty.

BIBLIOGRAPHY

BOOKS

Betrock, Alan. *Hitsville: The 100 Greatest Rock 'n' Roll Magazines, 1954-1968*. New York: Shake Books, 1991.

—. *The I Was a Teenage Juvenile Delinquent Rock 'n' Roll Horror Beach Party Movie Book*. New York: St. Martin's Press, 1986.

Bronson, Fred. *The Billboard Book of Number One Hits*. New York: Billboard Publications, 1988.

Doherty, Thomas. *Teenagers & Teenpics*. Boston: Unwin Hyman, 1988.

Duvall, Evelyn Millis. *Facts of Life and Love for Teen-Agers*. New York: Popular Library, 1956, [Revised Edition] 1957.

Miller, Mary Sue. *Here's to You, Miss Teen*. New York: Holt, Rinehart & Winston, 1960.

Palladino, Grace. *Teenagers: An American History*. New York: Basic Books, 1996.

Stambler, Irwin. *The Encyclopedia of Pop, Rock and Soul*. New York: St. Martin's Press, 1974, [Revised Edition] 1989.

Tosches, Nick. *Unsung Heroes of Rock 'n' Roll*. New York: Harmony Books, 1984, [Revised Edition] 1991.

Whitburn, Joel. *The Billboard Book of Top 40 Hits*. New York: Billboard Publications, 1985.

NEWSPAPERS AND MAGAZINES

Multiple issues of the following periodicals were consulted, certain of which are referenced in the text:

Click magazine

Dig magazine

Life magazine

Motion Picture Herald

Parents magazine

Seventeen magazine

Cool magazine

Ebony Song Parade

Look magazine

New York Times

Pic magazine

16 magazine

True Confessions